A Portrait of

VIET NAM

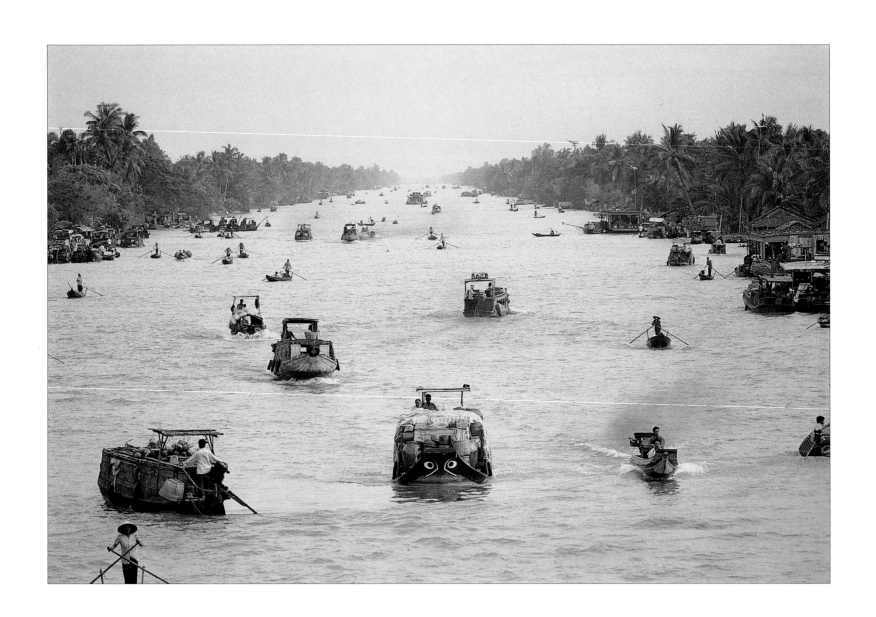

A Portrait of

VIET NAM

LOU DEMATTEIS

FOREWORD BY OLIVER STONE

**EPILOGUE BY LE LY
HAYSLIP**

*NOTES ON THE PHOTOGRAPHS
BY DANA SACHS*

W.W. NORTON & COMPANY · NEW YORK · LONDON

Also by Lou Dematteis with Chris Vail
Nicaragua: A Decade of Revolution

Also by Le Ly Hayslip
When Heaven and Earth Changed Places
Child of War, Woman of Peace

Frontispiece: Boats on a Mekong River canal near the town of Phung Hiep.

Copyright © 1996 by Lou Dematteis
Foreword copyright © 1996 by Oliver Stone
Epilogue copyright © 1996 by Le Ly Hayslip
Notes copyright © 1996 by Dana Sachs

The text of this book is composed in Palatino with the display set in Helvetica.
Composition by Gina Webster and Candace Maté
Manufacturing by C.S. Graphics PTE Ltd.
Book design by Candace Maté

Library of Congress Cataloging-in-Publication Data
Dematteis, Lou.
A portrait of Viet Nam / Lou Dematteis;
foreword by Oliver Stone; epilogue by Le Ly Hayslip;
notes by Dana Sachs.

p. cm.
1. Vietnam—Pictorial works. I. Title.
DS556.39.D46 1996
959.7–dc2 95-26107

ISBN 0-393-03948-X 0-393-31429-4 (pbk.)

W. W. Norton & Company, Inc., 500 Fifth Avenue, New York, N.Y. 10110
http://web.wwnorton.com
W. W. Norton & Company Ltd., 10 Coptic Street, London WC1A 1PU
1 2 3 4 5 6 7 8 9 0

CONTENTS

For my daughter

Gabriela

And in memory of

my brother my father
Robert J. Dematteis and Louis B. Dematteis

FOREWORD

by Oliver Stone

Oscar Wilde was not just joking when he said: "one duty we have to history is to re-write it." I often think the historian puts himself in a place of great sanctity and a certain pompousness in assuming that he knows better than anyone else. We see many cases of one history fighting another history, digging for the real "bones" of history. As if it were Schliemann's excavation of Troy, unearthing one layer after another—was it seven or nine layers?—through time. And because we find something to be truer in the twentieth century than it was in the nineteenth century, it doesn't necessarily make it true in the twenty-first century or the twenty-second century. I think of time—all time—as circular, in its revelation. Maybe things are never really explained except through subjective perceptions of the fashion of a time. In this day and age, it seems to be political correctness and a certain puritanism.

But, to my thinking, there is no logical separation of history and journalism from art. None of us has a lock on the truth. I think the work of the historian involves great gulps of imagination, and speculation, the resurrection of dialogues that frequently were never recorded. I am not trying to denigrate the work of the historian but rather to say that the good historian must know well how elusive this thing is—referred to all too cavalierly by journalists as "the truth."

The subjects I've chosen to deal with in my films—civil war in Salvador, the Viet Nam War, the assassination of President Kennedy, and the resignation of Richard Nixon—by their very nature force speculation. They are all shrouded in official secrecy, which has little to do with "national security" and much to do with protecting political reputations and concealing official crimes.

I am one of those who was sent to Viet Nam as a result of an officially endorsed lie, the infamous Gulf of Tonkin resolution. Viet Nam itself went through many different historical changes. When I was first there in 1965–66, it was a glorious border war, like the British in Afghanistan, like something Rudyard Kipling might have dreamed up. By 1969, it was the basis for Nixon's Guam doctrine, the withdrawal of American power, the new tightening of our commitments. By 1975, it was an embarrassing defeat. Viet Nam veterans were treated like lepers. By 1985, it was perceived

by many people as symptomatic of the decline of the American century and the American Empire. But then of course by 1994, it was again part of what I would call the special effect replacement history of *Forrest Gump*, a sort of glorious baptism by fire in which again we erased any symptoms of the warmongering disease from our psyche so that Forrest Gump as Voltairean innocent could walk through the American landscape in pursuit of his Holy Grail.

Experiences like this have left me suspicious of that first draft of history called journalism. I feel we have an obligation to transcend the data in order to attain the deeper interpretation that drama alone affords. This is what Shakespeare did. This is what Dickens did. My own view of the Russian Revolution is shaped by Eisenstein, the Mexican Revolution by Steinbeck and Brando and Wallace Beery, the French Revolution by Ronald Coleman and Charles Dickens. Generally speaking, history has been this collection of myths, this perception laid out by the intelligentsia of the time, those who had the exclusive ability to write and communicate and control the reins of power and publishing, and it is *crucial* we question this basis of history. "Who shall guard the guardians themselves?" Juvenal asked. "Who shall guard the guardians themselves?"

Don't get me wrong. I believe in doubt but not cynicism. What is the obligation of the artist to truth? First off to pursue it. We must bring our heartfelt effort to comprehend the human experience. Our characters must grow through encounters with their surroundings. As we explore emotions and thoughts and circumstances, we must also pay homage to the mysteries of our makeup that are not so easily known. For that reason I think drama is a difficult process, which must always be evolving, contradictory, and ultimately sometimes *unsatisfying*. That is its appeal and its curse.

As F. Scott Fitzgerald implied in his *Great Gatsby*, time is very elusive and nostalgic. "We beat on—as the future, year by year, recedes before us, boats against the current, borne ceaselessly back into the past." The future, as does the past, continues to elude us now. And tomorrow we will run faster, and stretch our arms further. And that is the way it is supposed to be. We all know the truth. The truth is that none of us really know. This book, by Lou Dematteis, is one step in the direction of liberating ourselves from our past.

Of the twelve motion pictures directed by Oliver Stone, three have been about the war in Viet Nam and its aftereffects: Platoon *(1986),* Born on the Fourth of July *(1989), and* Heaven and Earth *(1993).*

VIET NAM

by Lou Dematteis

Viet Nam is embedded deep in the American psyche. To many people, it is a name that brings to mind haunting images of a brutal war in a far-off corner of Southeast Asia. To some of those who supported the war, it is a humiliating memory, the nation's first military defeat. To those who opposed the war, the memory is of a tragic and immoral blunder. And for a good number of the soldiers who fought the war, it is one that has never really ended. Major motion pictures, televisions dramas, and countless books about Viet Nam have taught us much about the American War in Indochina, but precious little about the Vietnamese people themselves. This book of photographs attempts to plug some of this information gap by presenting the faces and places of Viet Nam today. Focusing on the daily lives of ordinary people, this work documents a country of over 72 million inhabitants, offering a portrait of a gracious people who were once considered America's most implacable foe and who now look to a future of friendship and cooperation.

Traveling to Viet Nam for the first time in 1992, I found a country exotically new yet strangely familiar.

Images of the Viet Nam War, broadcast by television into America's living rooms in the sixties and seventies, were still vivid and sharp in my memory. The war in Viet Nam was the war of my generation and had profoundly affected my life. As a young man, I actively opposed the war over a period of many years. Ironically, having never fought in the Viet Nam War, I later ended up covering several other wars. From 1985 to 1990, I lived in Central America, where I worked as a photojournalist. From my base in Managua, Nicaragua, I covered the Contra war in that country, as well as the war in El Salvador and the conflicts in Haiti and Panama. The exposure year after year to a seemingly endless cycle of death and destruction took a high personal toll. In the end, I left this area of photojournalism, determined to focus my camera on subjects which, while still vitally important, did not involve the taking of human life. One idea I had been pursuing was to photograph in Viet Nam, and the opportunity came in 1992 when I received an invitation from the Vietnamese Photographic Artists Association to visit and document their country. In this way, never having seen Viet Nam at war, I now had the

chance to see the land at peace.

As an American, I was concerned with how I might be received in Viet Nam, by officials and average citizens alike. Travelling first to Hanoi, whose Noi Bai Airport is still surrounded by bomb craters, now being used by the local farmers as fish ponds, I wouldn't have been surprised to experience coolness, if not outright hostility, to my visit. As a photographer, working mostly in public and often alone, it was not unreasonable to expect some sort of incident or problem. In the end, my concerns turned out to be unjustified. Throughout my stay and throughout the country, I received a gracious and warm reception. Far from regarding me with hostility, almost everyone I met, from every walk of life and regardless of political perspective, was quick to express a desire for reconciliation and friendship with the United States. And this after the death and destruction of the war, and a punishing, decades-long trade embargo which was then still in force. This attitude of the Vietnamese reminded me so much of Nicaragua. During my years covering the Contra war there, a devastating conflict orchestrated and financed by the Reagan administration, I was in constant amazement over the generosity of the Nicaraguan people, who befriended and protected those of us from the United States who were guests in their country even while the brutal policies of our own government tore that country apart. I ask, would we be so generous?

That the Vietnamese wanted to be our friends should not have come as much of a surprise. The Viet Minh under Ho Chi Minh joined with the United States during World War II in opposing the Japanese occupation of Indochina. Ho's fighters were trained, supplied, and directed by the U.S. Office of Strategic Services (OSS). In what is a great historical irony, the Viet Minh even helped U.S. flyers downed over Indochina make their way back to safety in China. The Vietnamese Declaration of Independence, promulgated by Ho Chi Minh in Hanoi on September 2, 1945, begins with a passage borrowed from our own: "All men are created equal. They are endowed by their Creator with certain unalienable rights; among these are life, liberty, and the pursuit of happiness." In addition, in 1945–46, Ho repeatedly attempted to enlist American support for an independent and nonaligned Viet Nam. It is a real tragedy of history that our two countries became such sworn enemies, primarily as a result of the misguided, misinformed, dishonest, and callous policies of the U.S. government. U.S. involvement in Viet Nam lasted until the morning of April 30, 1975, when the city of Saigon fell to North Vietnamese and National Liberation Front forces. The last American diplomats and soldiers had been evacuated by helicopter to U.S. ships stationed offshore only hours before.

Americans first began returning in some numbers to Viet Nam in the mid- to late 1980s. Among the first were U.S. veterans of the war. Traveling in groups as part of special tours, the veterans were received openly and with understanding by the Vietnamese people and government. The Vietnamese have great sympathy for U.S. veterans (more than is often

found in the United States), no doubt in part because of the shared suffering both the veterans and the Vietnamese people endured during the war. Many vets have returned to work on humanitarian projects, often alongside Vietnamese veterans who were once their enemies. The return to Viet Nam has provided these American vets with the opportunity to help heal deep psychological wounds.

While today we hear much about Viet Nam's opening to foreign investment and tourism, there are other areas, perhaps more important, where the Vietnamese need our assistance and cooperation. Two examples are health and the environment. Twenty years after the end of the war, Viet Nam is still dealing with the lingering and often harrowing effects of the extensive use by the United States of the deadly defoliant Agent Orange. For years Vietnamese doctors and health officials have called for an exchange of information and joint research on how to deal best with the chemical's lethal legacy. In the area of environmental protection, there is a great need and opportunity for cooperation as the Vietnamese struggle to protect their environment and natural resources from the damages wrought by rapid economic growth and population increases.

The relationship between the United States and Viet Nam is linked by blood and forged by fire. It is one that will endure and transform itself for many generations to come. Now is the time for the healing of wounds, not only between Vietnamese and Americans, but also between the people of a divided Vietnamese community, more than 900,000 of whom reside in the United States. And this has

begun to happen as more and more *Viet Kieu* (overseas Vietnamese) return to visit their homeland, and even stay on to help rebuild their country.

The photos in this book are from trips I made to Viet Nam from 1992 to 1995, an important point in Viet Nam's history. After a long period of isolation, partially self-imposed and partially as a result of the U.S. trade and diplomatic embargo, Viet Nam has just in the last few years begun opening its doors to the world. Along with this opening, the nation has been experiencing an internal liberalization, which is releasing great energy and ushering in dramatic changes in the economic, social, cultural, and artistic spheres. When you add to this the fact that over these years the situation between Viet Nam and the United States has steadily improved, culminating with the normalization of relations by President Bill Clinton on July 11, 1995, you have a unique period in Viet Nam's history, which has special significance for the United States as well. I feel very fortunate to have traveled throughout the country to document these changes, as well as to chronicle some of the timelessness of Vietnamese life and culture. As Viet Nam changes even more rapidly in the future, this time will be seen as a precious moment of heightened drama when the old Viet Nam began transforming itself—renewing the past and embracing the future, moving ahead never to turn back.

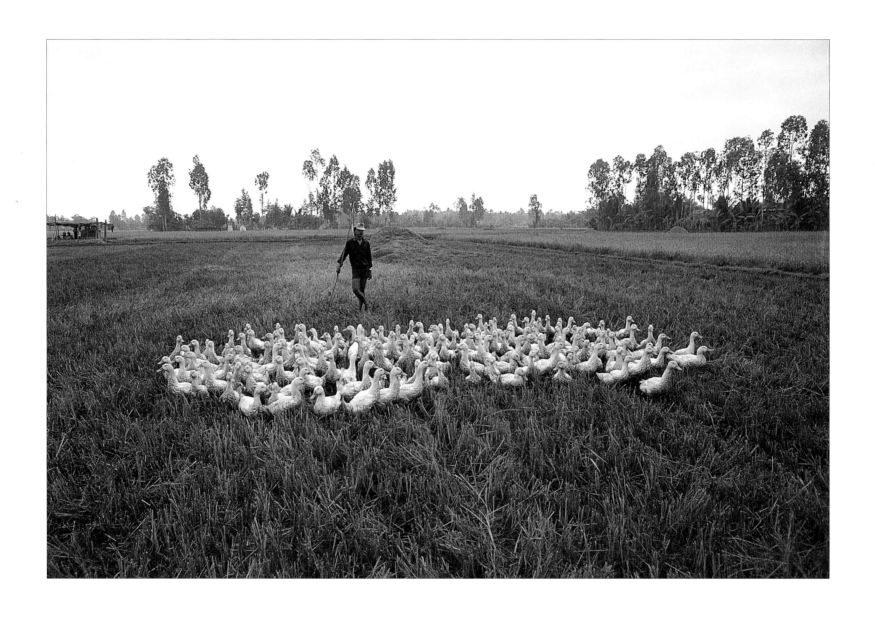

Farmer with ducks. Mekong Delta.

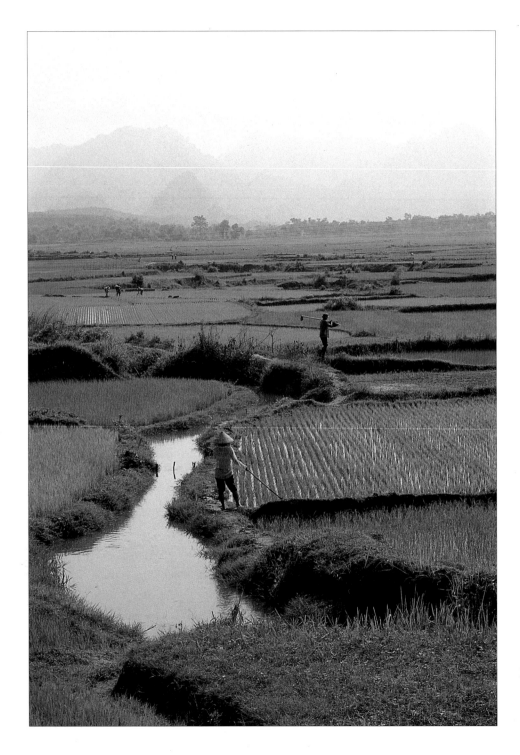

Rice paddies. Tuyen Quang Province.

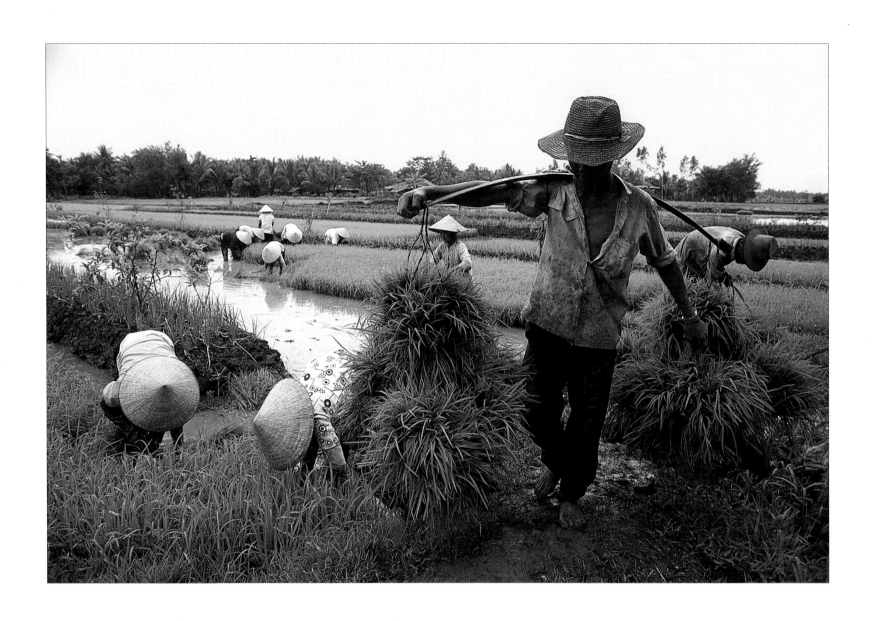

Transplanting rice seedlings. Mekong Delta.

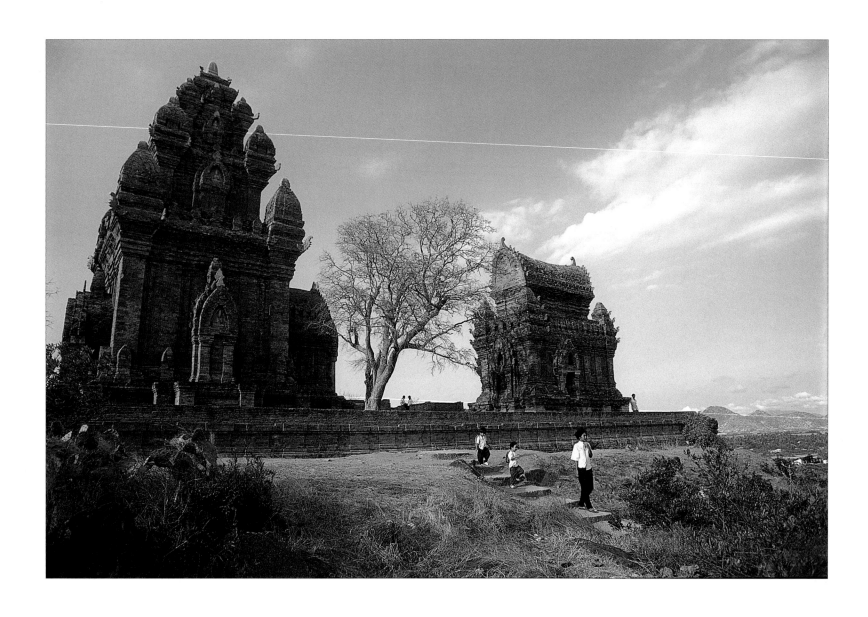

Cham Towers. Phan Rang.

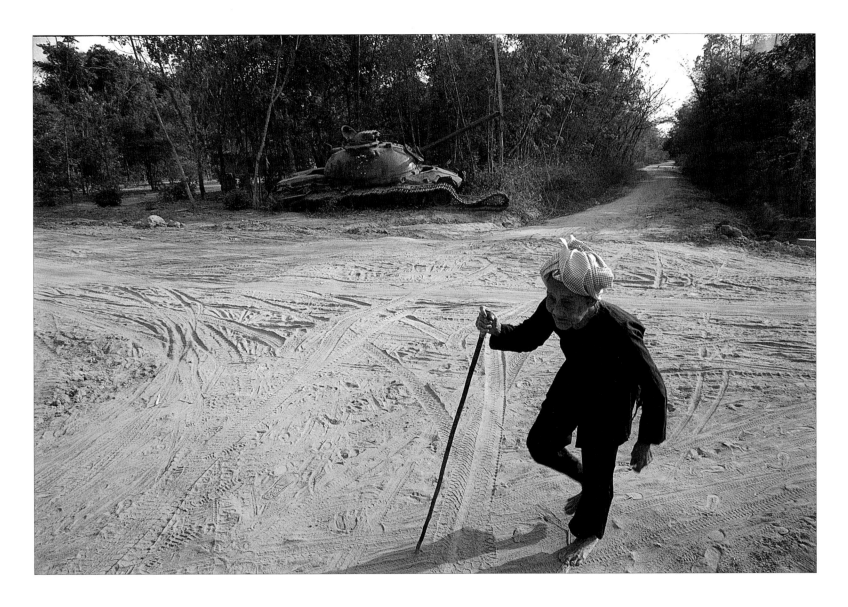

A woman walks past a destroyed U.S. M–48 tank in Song Be Province north of Ho Chi Minh City. In 1967, this tank was abandoned by U.S. forces after being disabled during a battle in this region then known as the Iron Triangle.

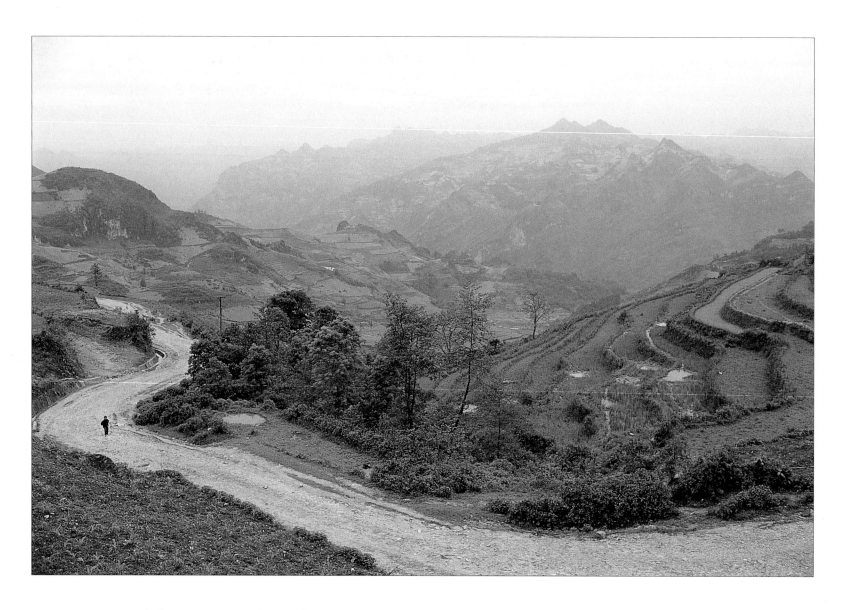

With the mountains of China in the far background, a boy walks down a road near the town of Si Ma Cai in the border province of Lao Cai.

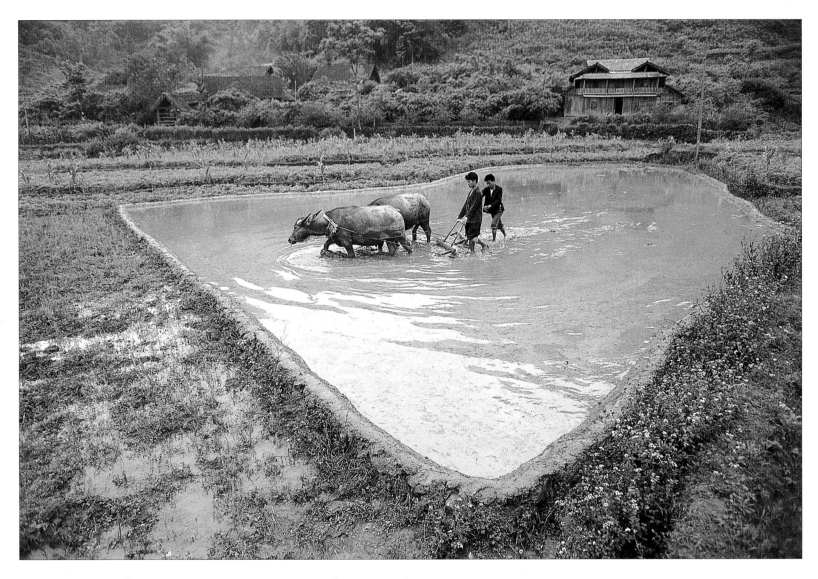

Ethnic Tay farmers plow a rice paddy in their village of Na Hoi in Lao Cai Province.

Overleaf: The anchored houseboats of fishermen in Halong Bay.

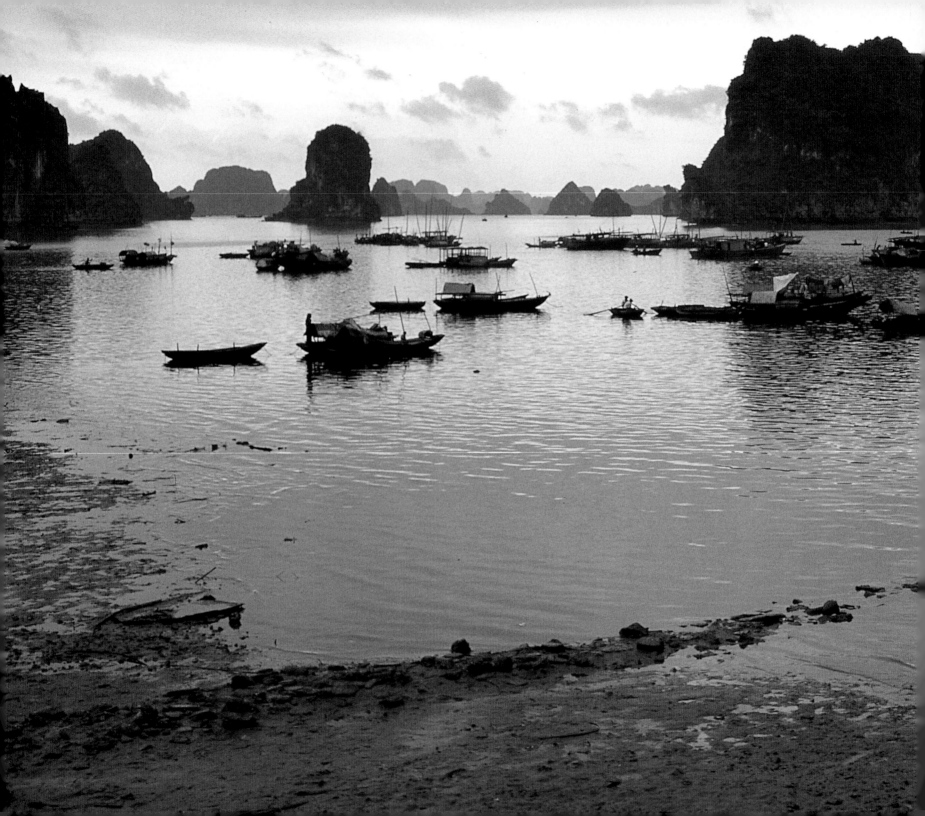

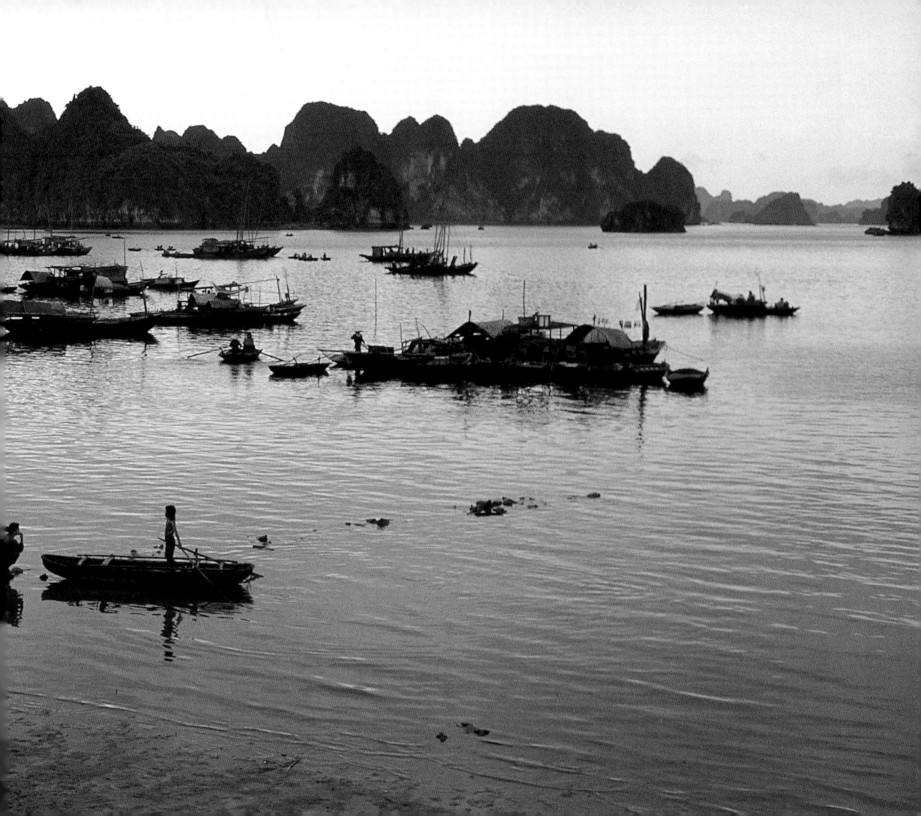

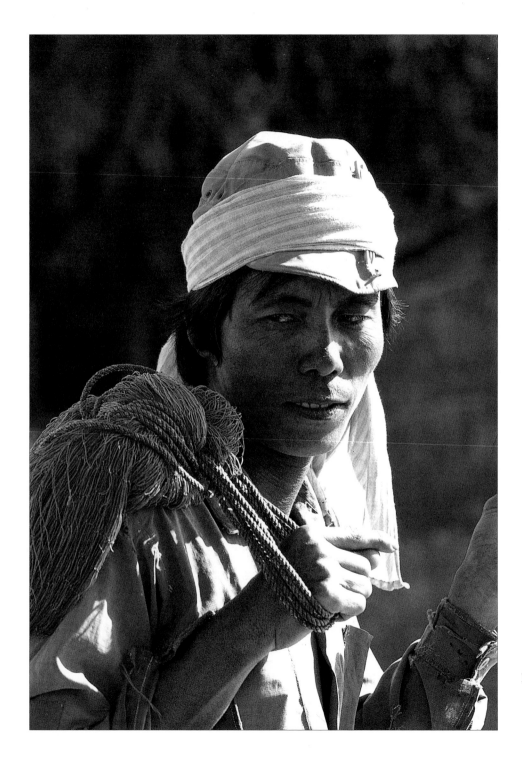

Fisherman near of Chau Doc in the Mekong Delta.

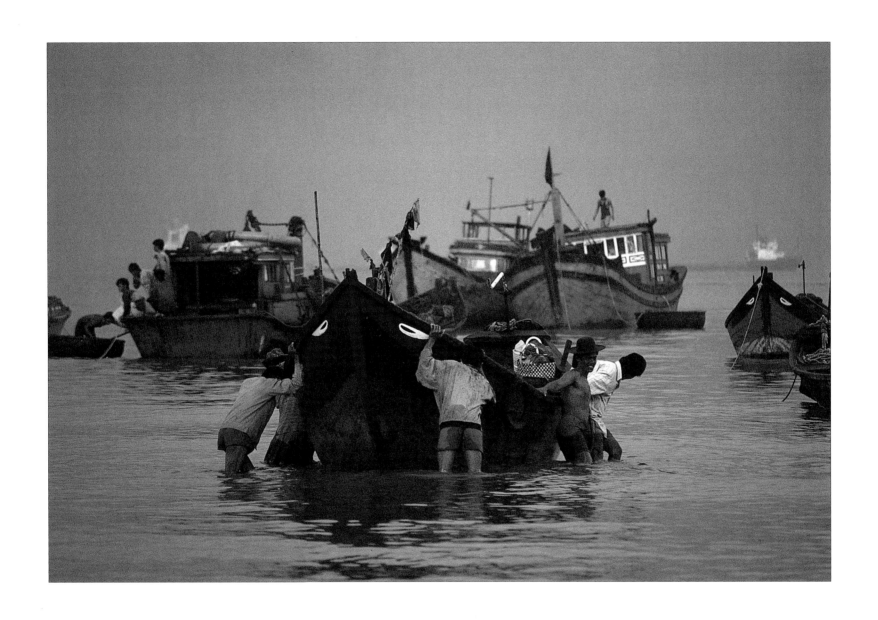

Fishermen putting out to sea. Vung Tau.

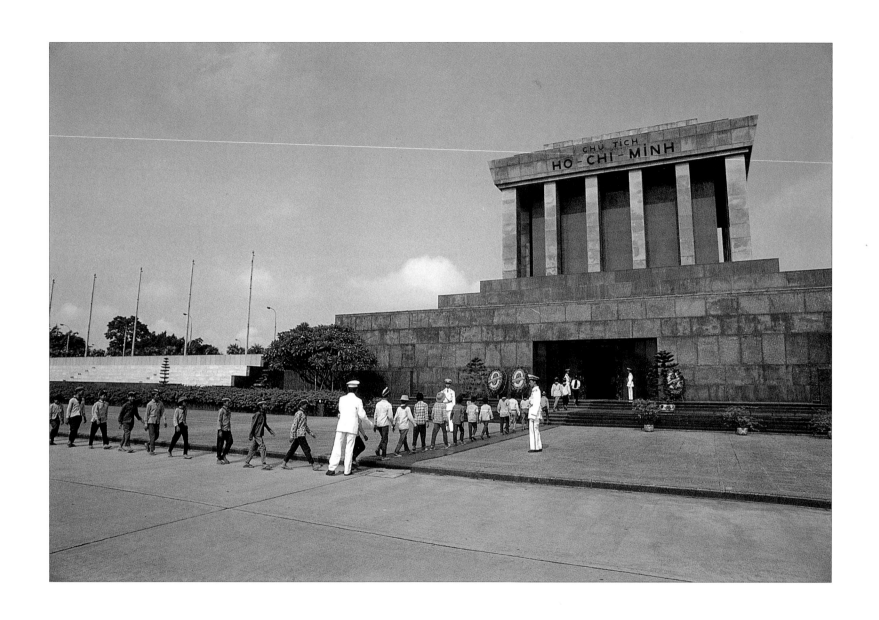

Schoolchildren entering Ho Chi Minh's Mausoleum. Hanoi.

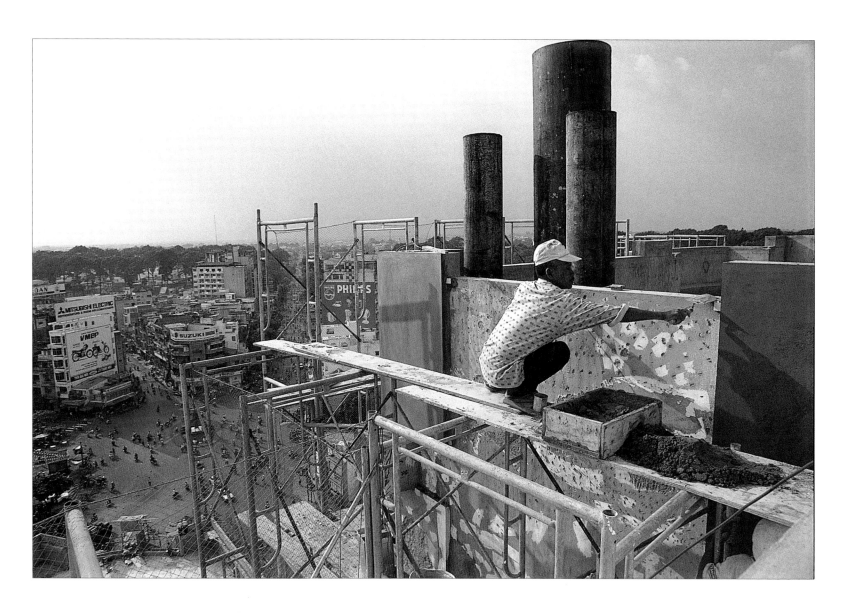

A mason works on the 541-room New World Hotel, a joint venture between the government of Viet Nam and a Hong Kong hotel corporation. Ho Chi Minh City.

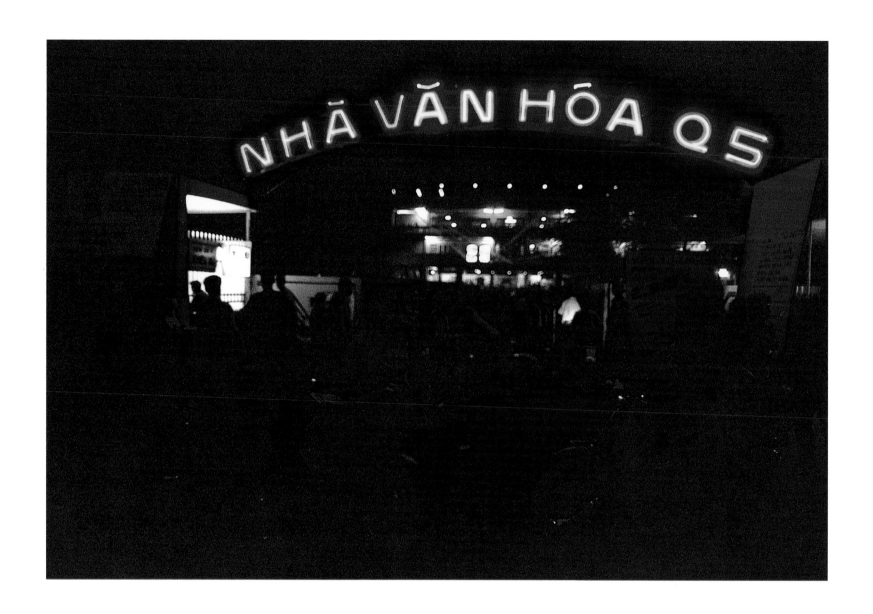

Youth in front of the District Five Cultural House on a Saturday Night. Ho Chi Minh City.

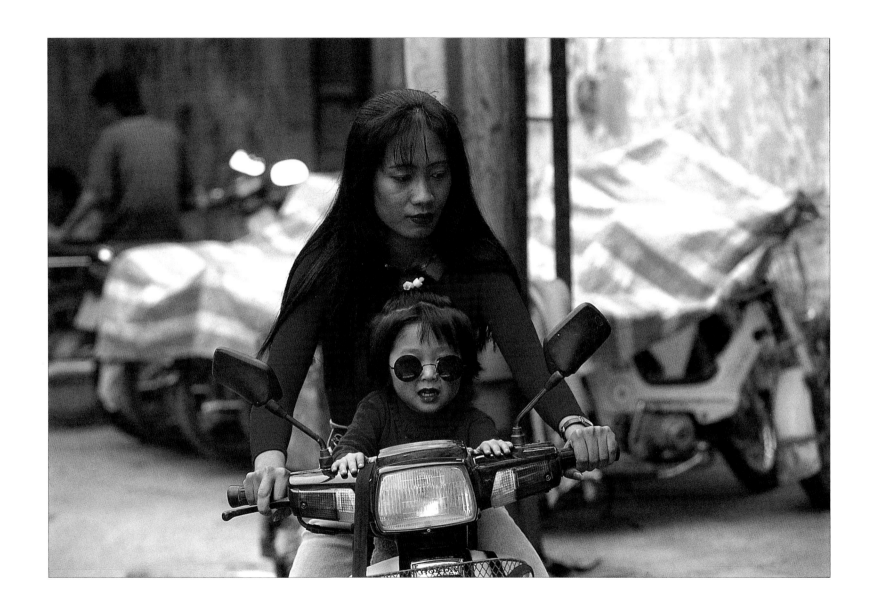

Mother and daughter. Hanoi.

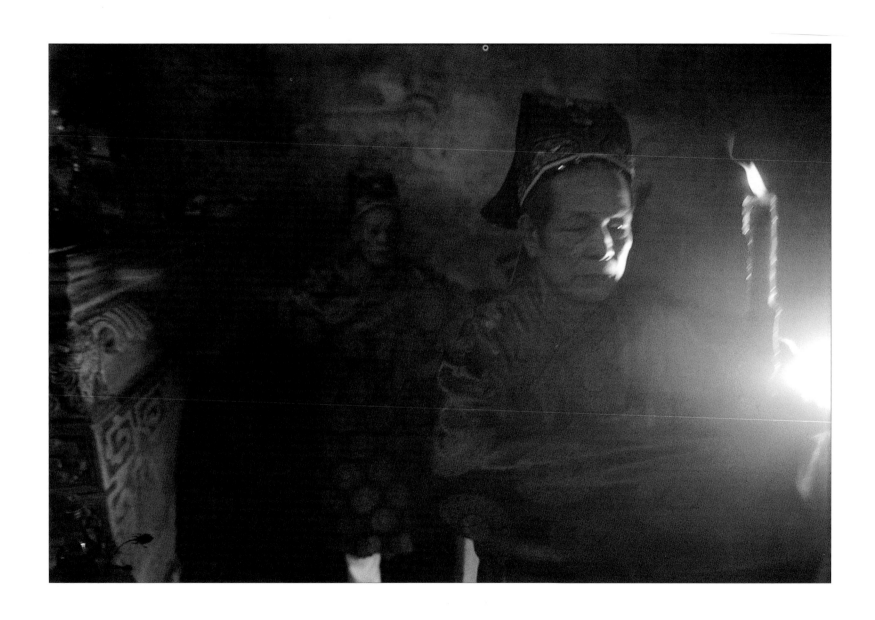

Village elders perform a religious ceremony at a shrine in Mai Dong village near Hanoi.

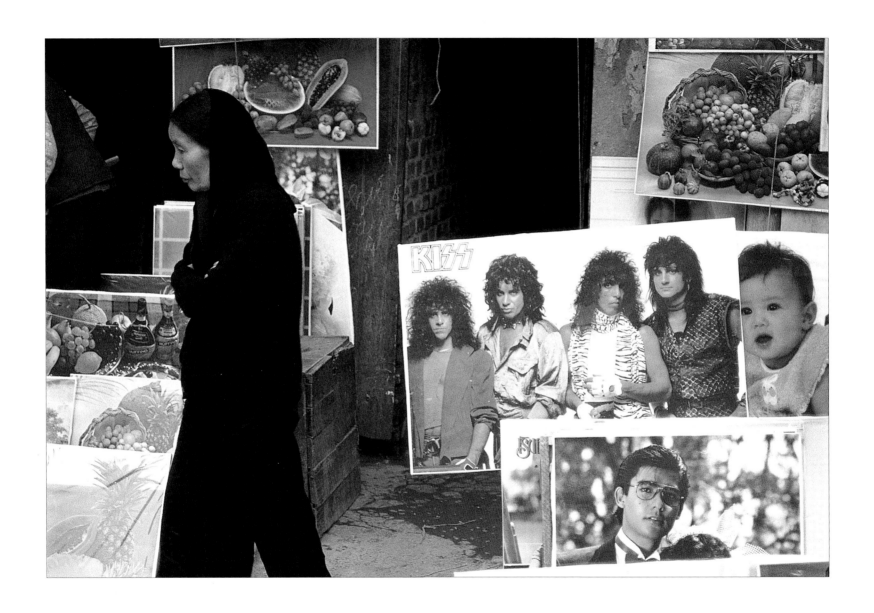

Sidewalk vender. Hanoi.

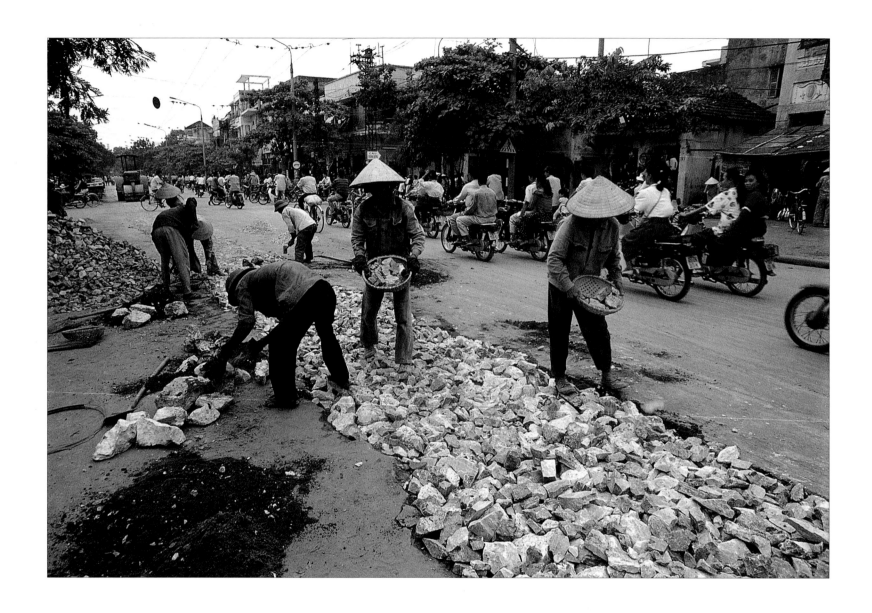

Street repair. Hanoi.

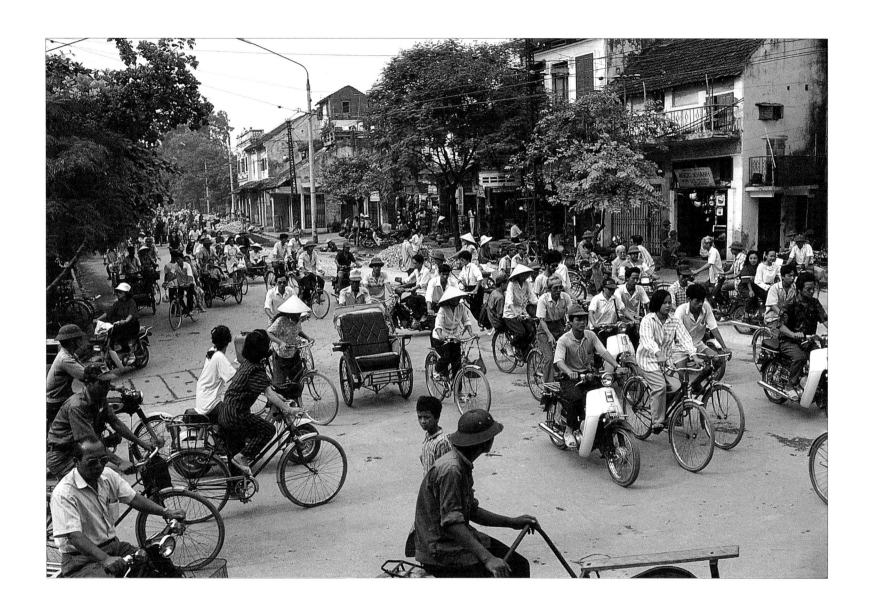

Rush-hour traffic on Hue Street. Hanoi.

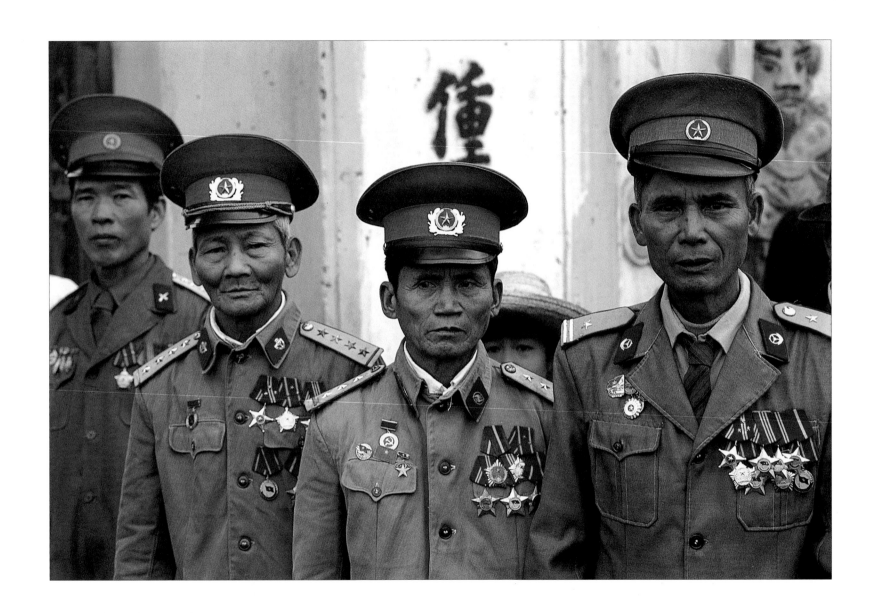

Veterans of the French War stand in front of a shrine in the village of Co Dien near Hanoi.

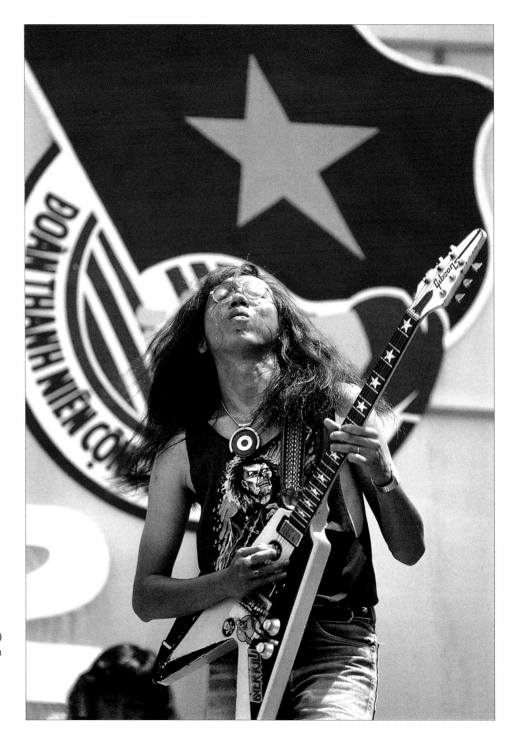

Nguyen Dat of the rock group *Da Vang* (Yellow Skin)
performs at a concert sponsored by the Ho Chi Minh
Communist Youth League. Ho Chi Minh City.

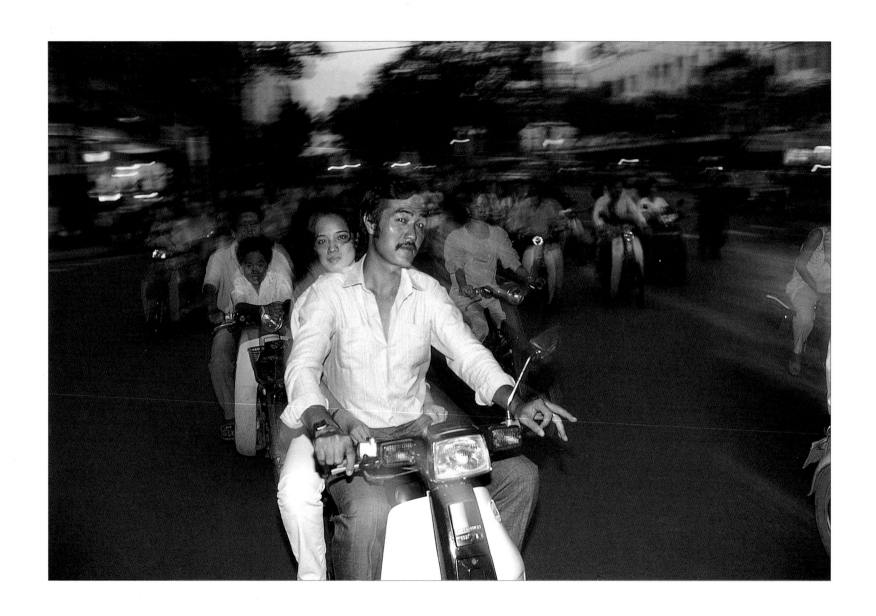

Cruising downtown on a Sunday night. Ho Chi Minh City.

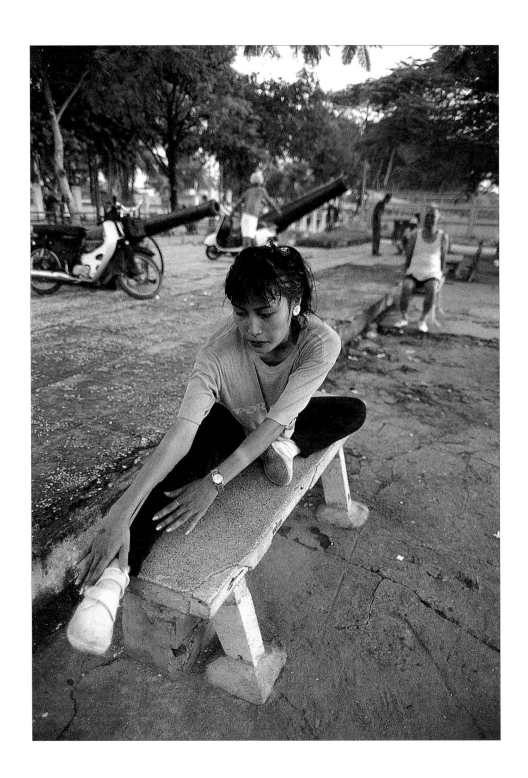

Morning exercises. Ho Chi Minh City.

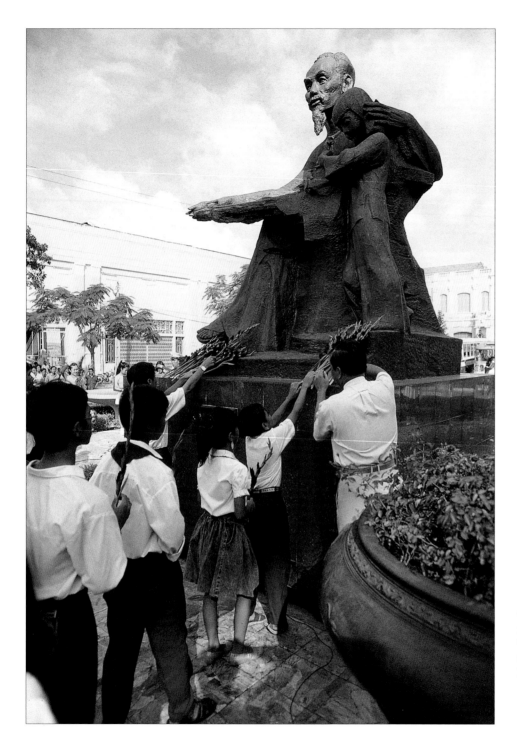

Children lay flowers on a statue of Ho Chi Minh during National Day celebrations held to commemorate the proclamation of the Declaration of Independence of the Democratic Republic of Viet Nam by Ho Chi Minh on September 2, 1945. Ho Chi Minh City.

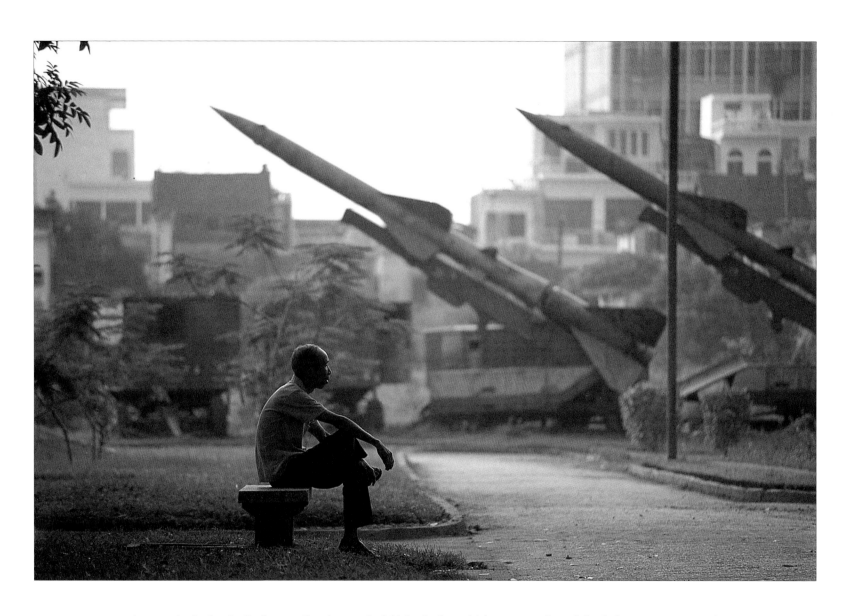

A man sits in Lenin Park near Russian-made SAM missiles which were used to defend the city against U.S. bombers during the American War. Hanoi.

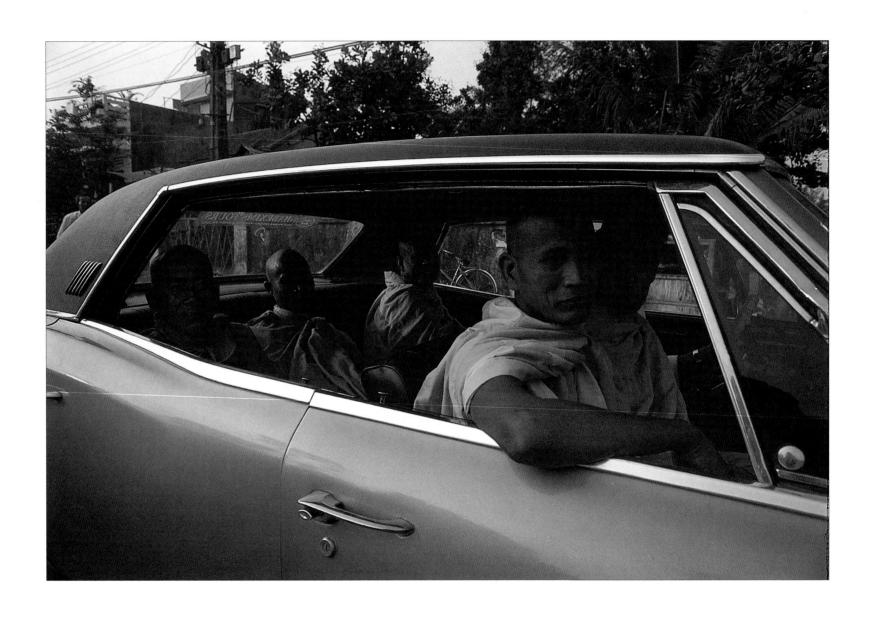

Buddhist monks ride in a funeral procession. Hoi An.

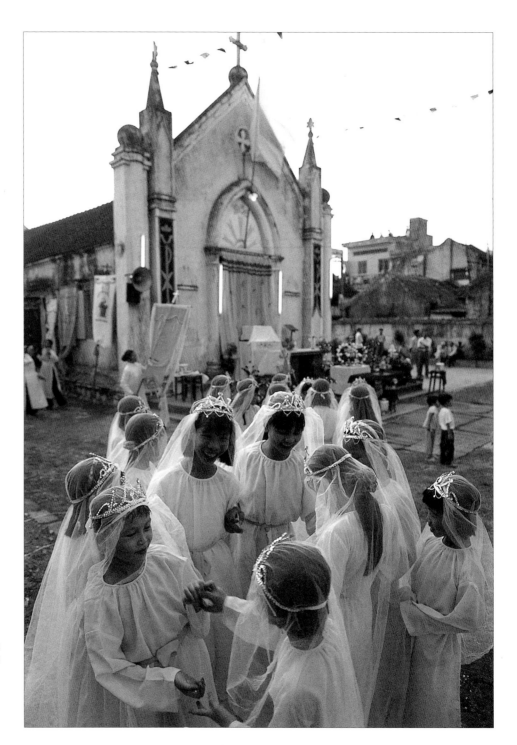

Young girls talk before the start of a procession at a
Catholic church during the celebration of the Flowers
for Mary festival. Haiphong.

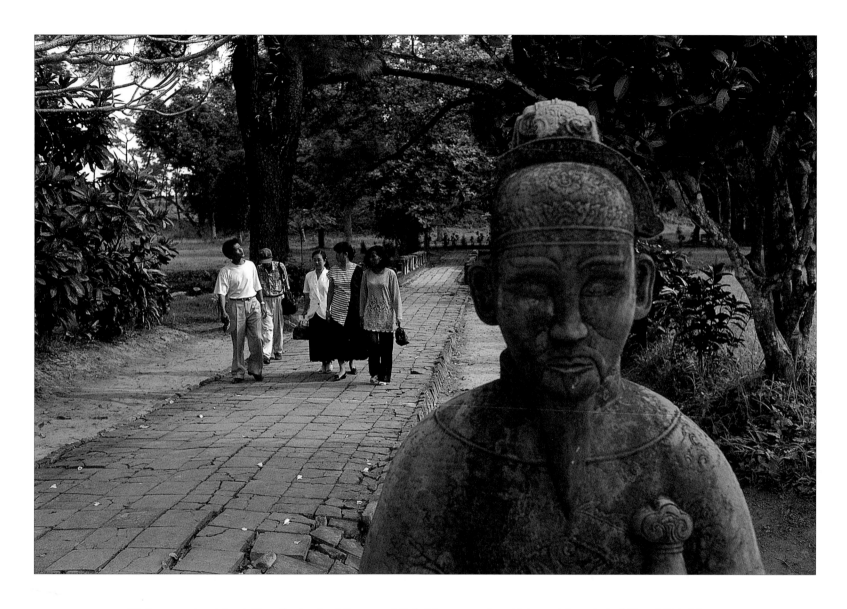

Vietnamese tourists visiting the tomb of Emperor Minh Mang near the old imperial capital of Hue. Minh Mang ruled Viet Nam in 1820–40.

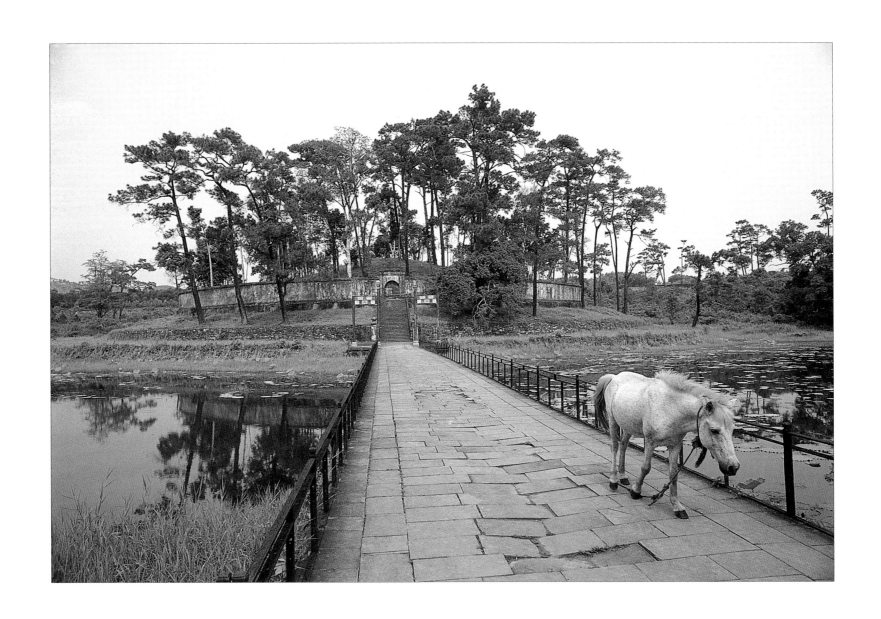

Stone bridge across Tan Nguyet Lake (Lake of the New Moon) leading to the sepulcher of Emperor Minh Mang.

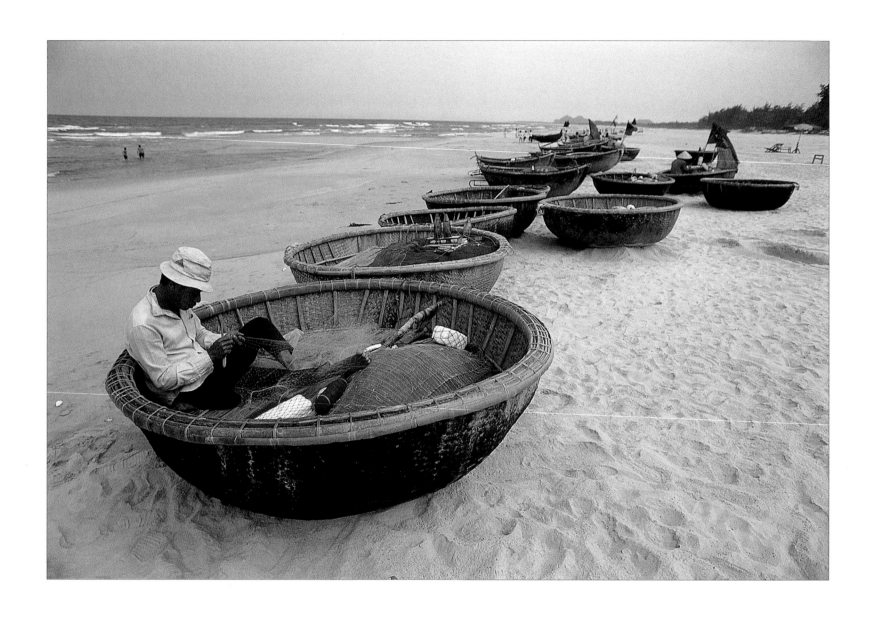

A fisherman mends a net as he sits in his small bamboo boat on My Khe Beach. Danang.

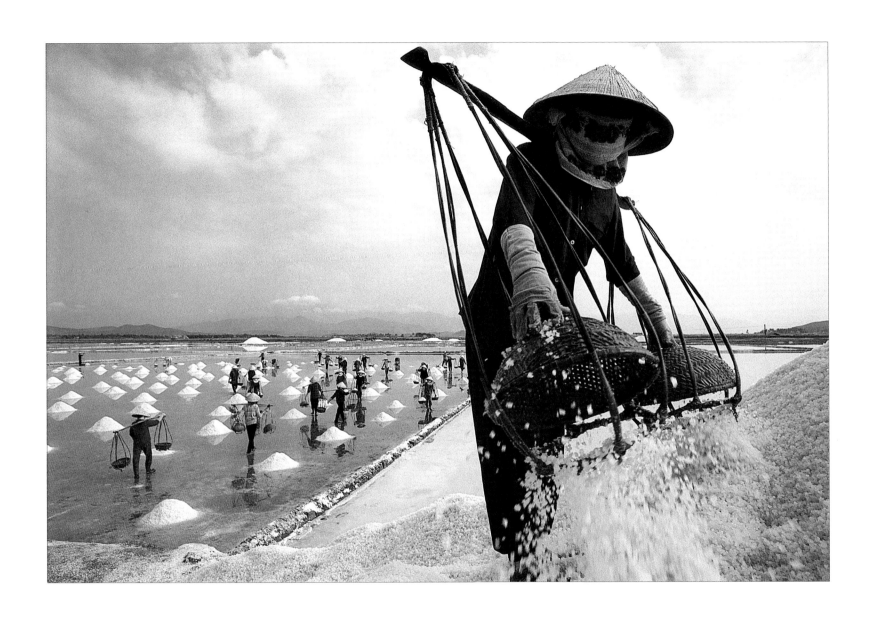

A worker adds to a mountain of salt at the Hon Khoi Salt Export Factory on the coast north of Nha Trang.

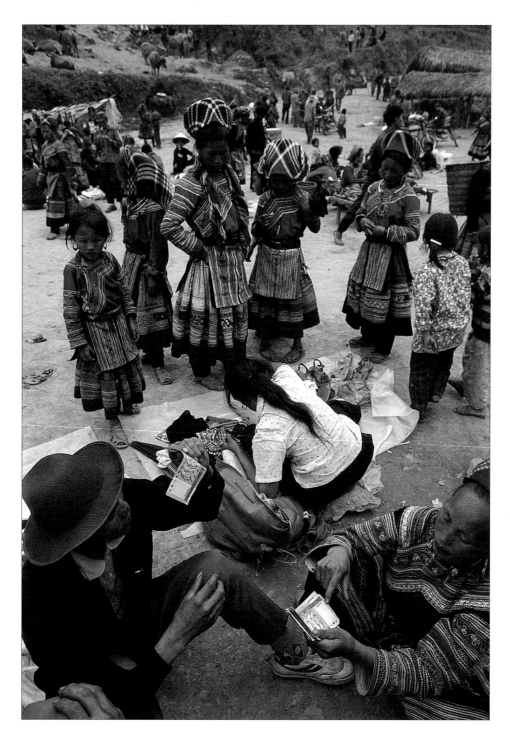

At the weekly market at Can Cau in Lao Cai Province, two traders, members of the Hmong minority, check out Chinese bank notes.

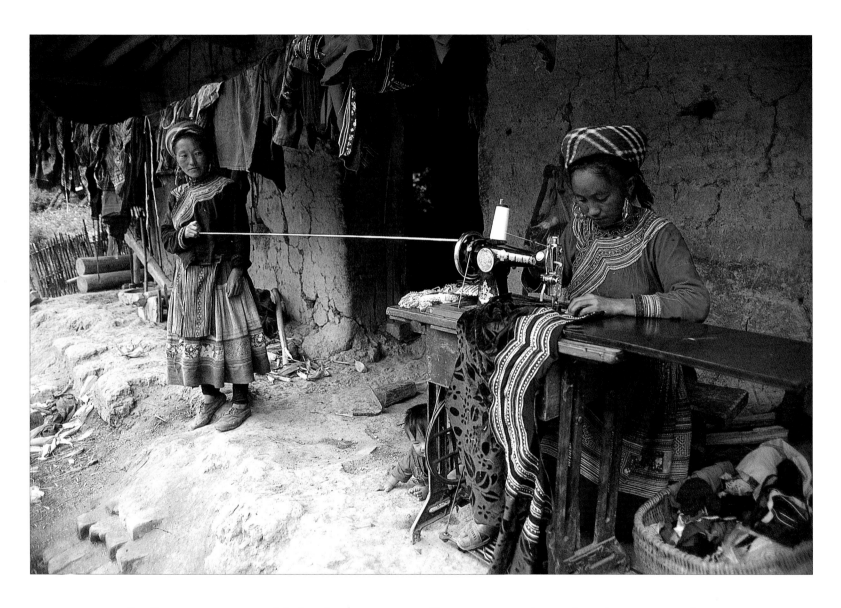

One Hmong woman sews while the other spins yarn on a Chinese sewing machine at their village of Hoa Xi Phang in Lao Cai Province. The Hmong are one of Viet Nam's 54 ethnic groups.

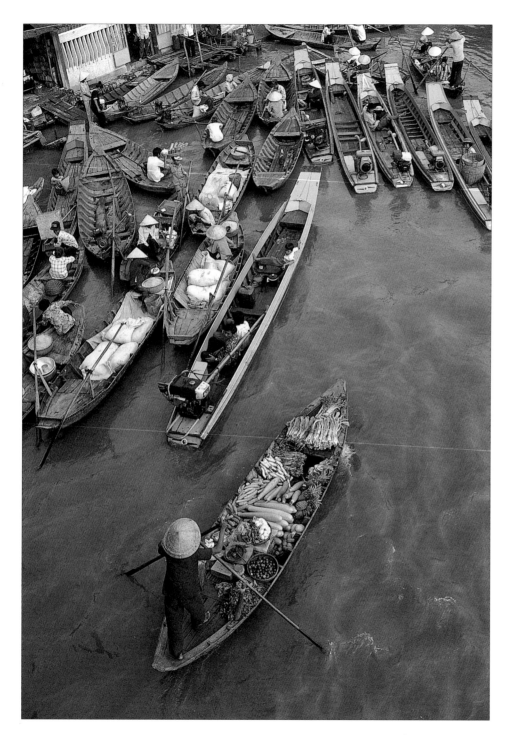

A boat loaded with fruits and vegetables moves toward the riverbank at Phung Hiep in the Mekong Delta. Farmers and traders come from all over the delta to trade and sell their goods at this market town where seven canals converge.

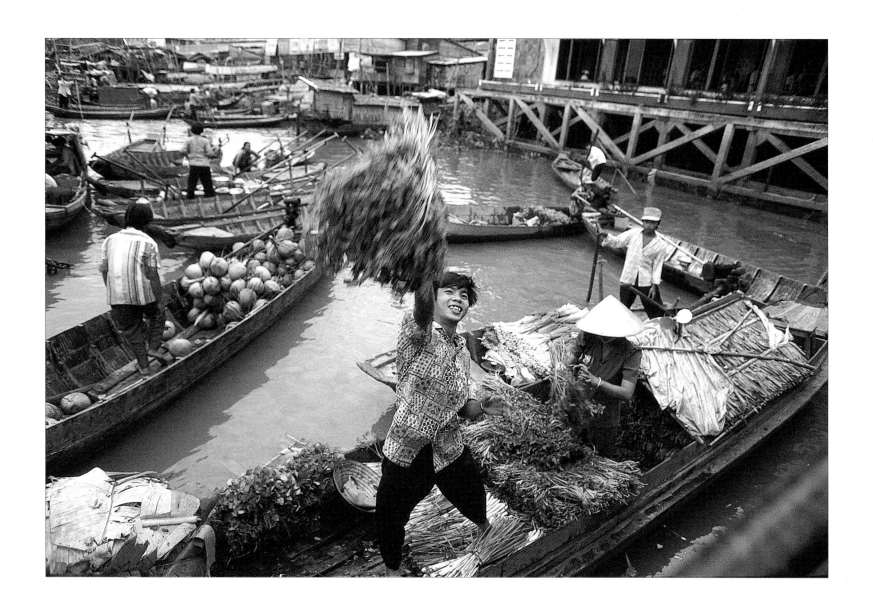

A boatman unloads his cargo of vegetables at the wharf of the Mekong Delta city of Can Tho.

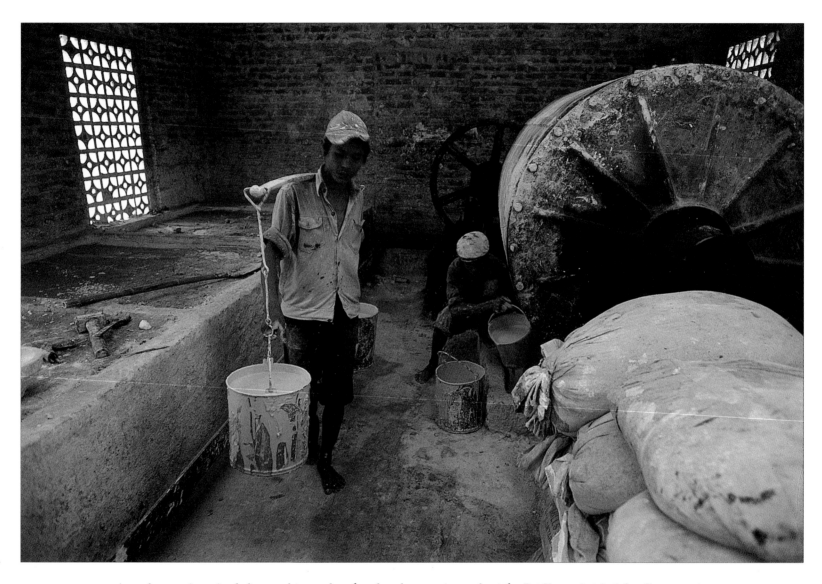

A worker carries mixed clay used to produce handmade ceramic goods at the Bat Trang Art Articles Company in the village of Bat Trang near Hanoi. This village along the Red River has been producing ceramic ware for over five hundred years.

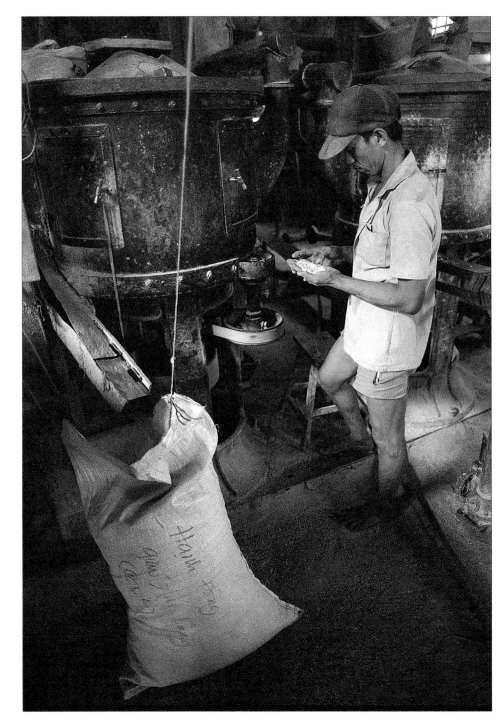

Rice mill. Can Tho, Mekong Delta.

Overleaf: Woman walks across coastal sand dunes near the village of Mui Ne north of Phan Thiet.

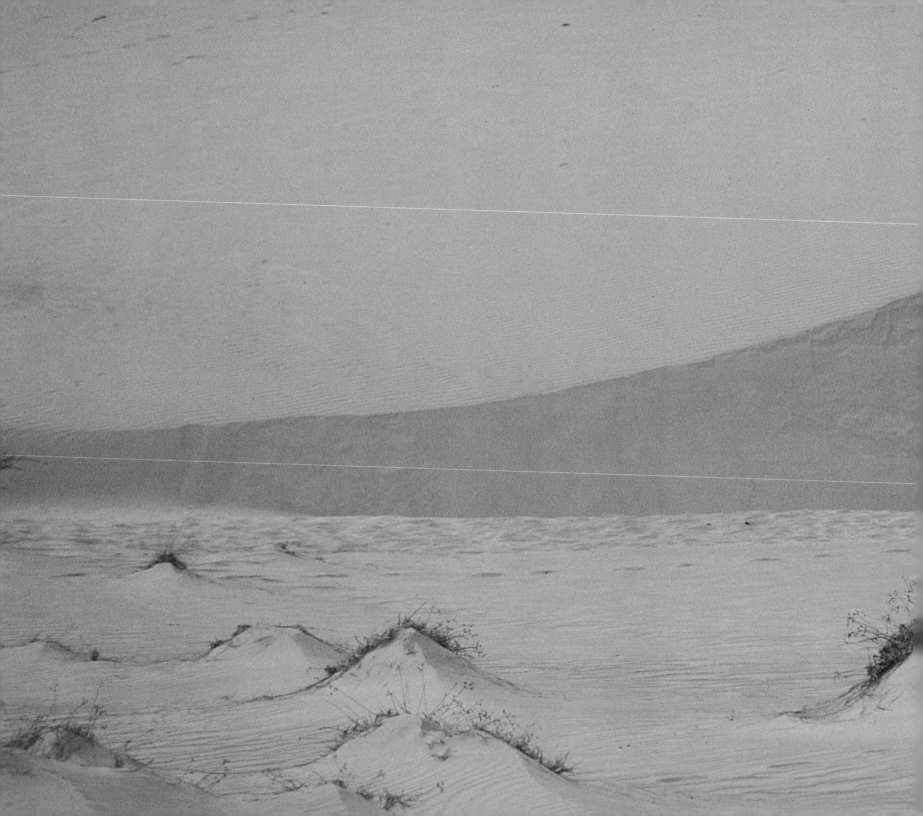

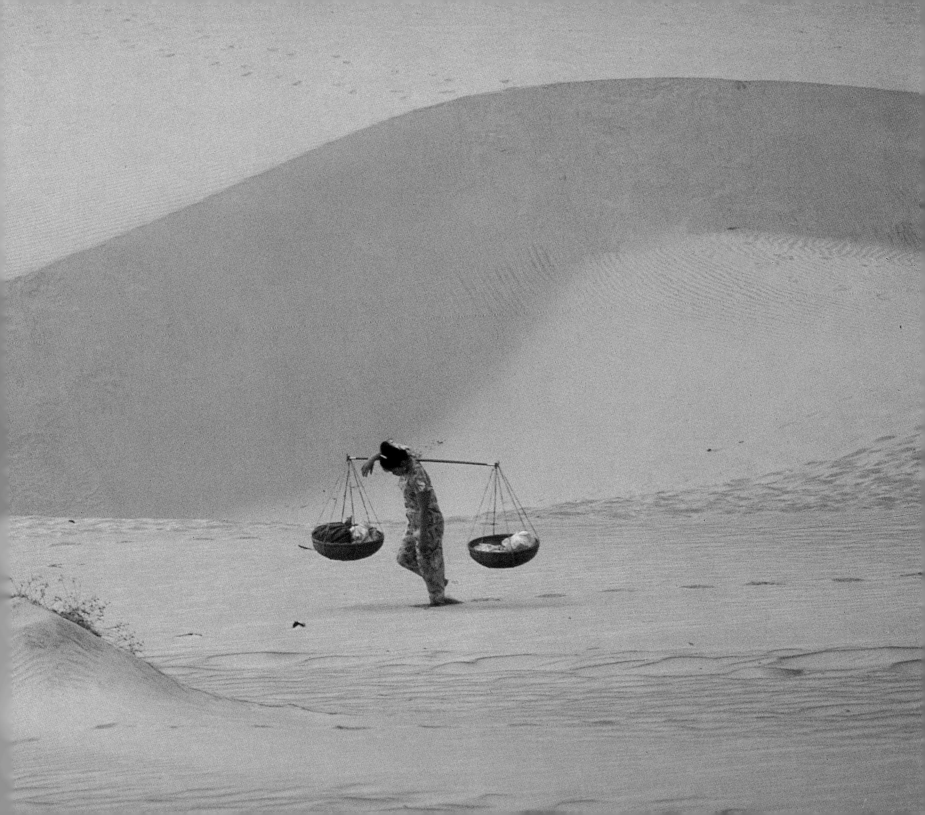

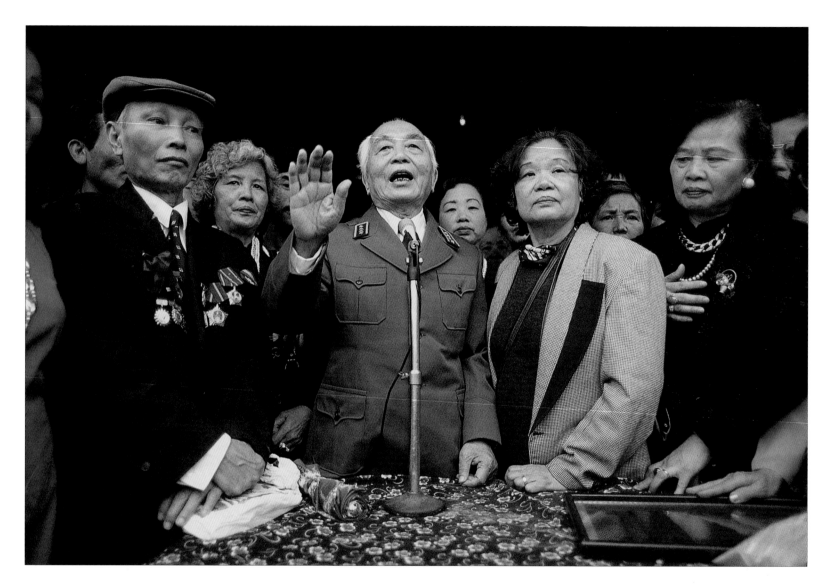

Vietnamese national hero General Vo Nguyen Giap speaks at a festival honoring two tenth-century Vietnamese generals at Co Dien village near Hanoi. A contemporary of Ho Chi Minh's, General Giap was the architect of Viet Nam's military victories over both the French and the Americans.

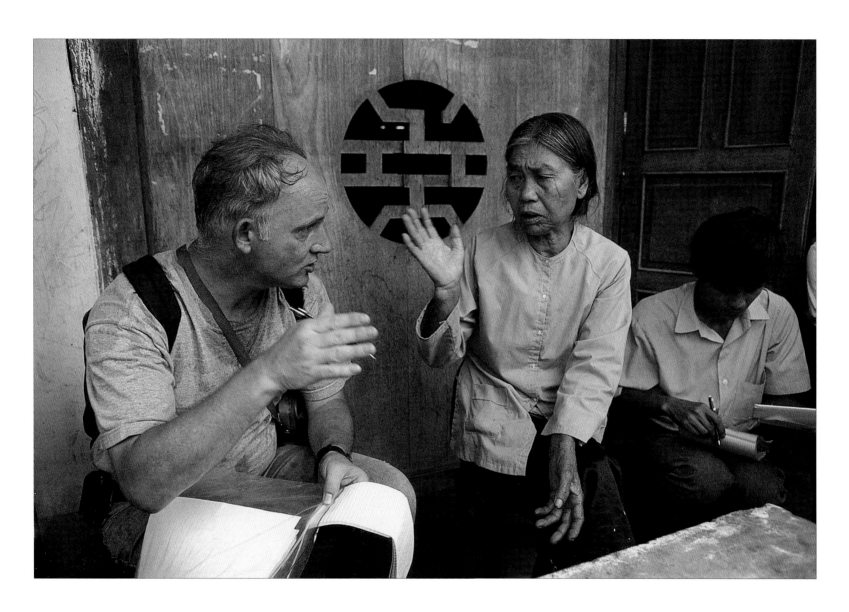

U.S. Joint Task Force–Full Accounting Team member interviews a Vietnamese civilian as he investigates the disappearance of an American listed as Missing In Action in Viet Nam in Dong Nai Province near Ho Chi Minh City.

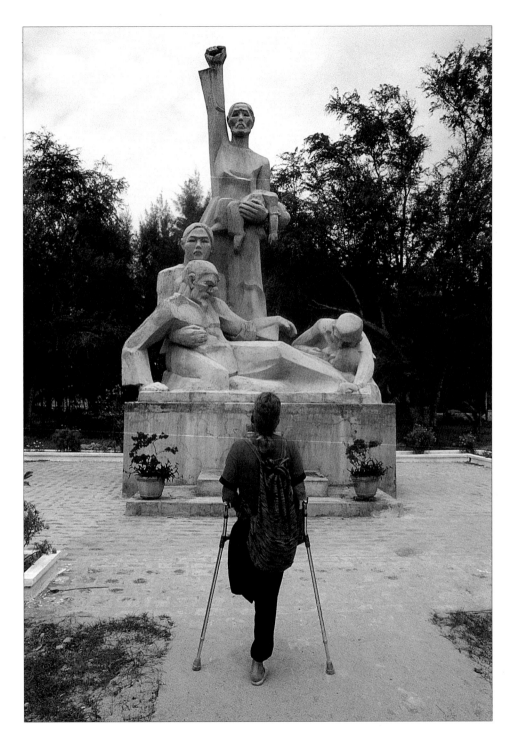

U.S. Viet Nam War veteran Daniel Cunningham visits the memorial to the victims of the My Lai Massacre at Son My in Quang Ngai Province. On March 16, 1968, U.S. troops killed some 347 unarmed Vietnamese civilians, including women and children.

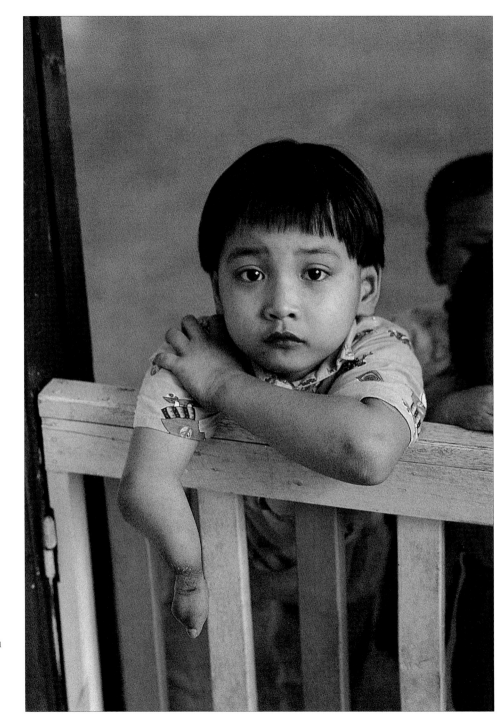

Child suffering the effects of Agent Orange at the Tu Du Women's Hospital. Ho Chi Minh City.

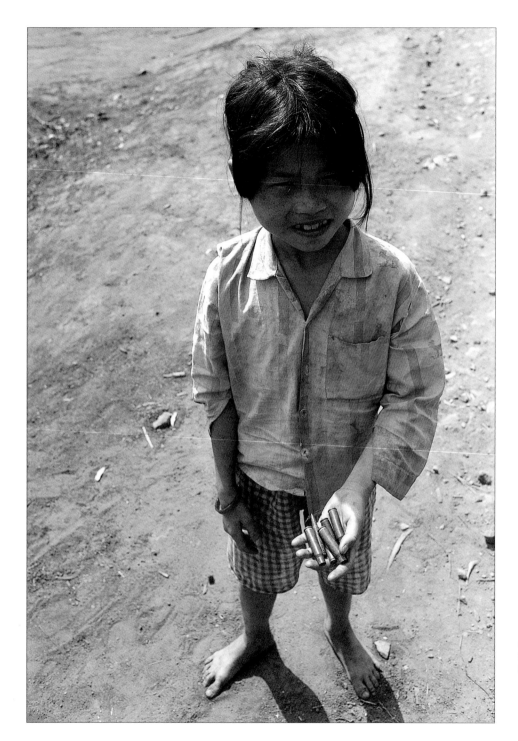

A young girl offers for sale spent bullets and at least one live one at the entrance to the former U.S. Marine Combat Base at Khe Sanh.

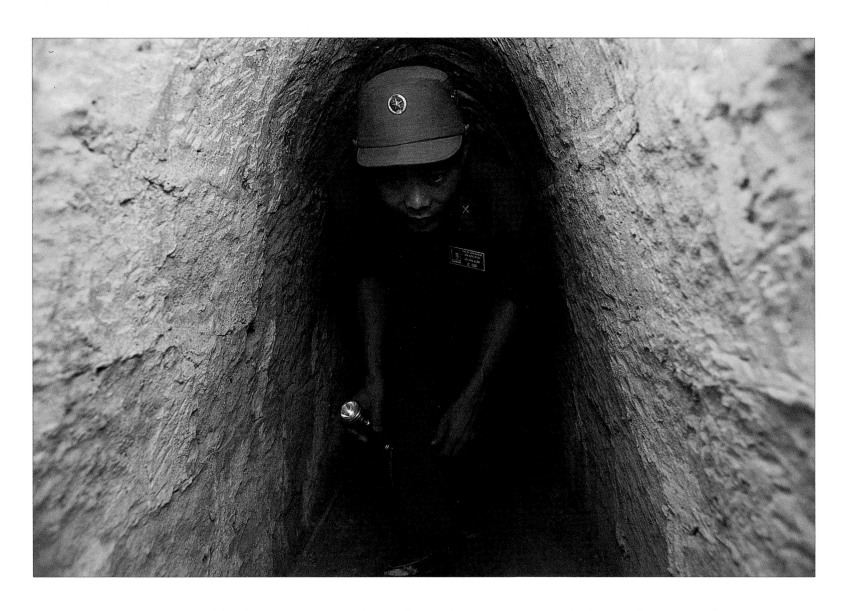

A Vietnamese soldier, doubling as a tour guide, crawls through a passageway at the Cu Chi tunnel complex north of Ho Chi Minh City.

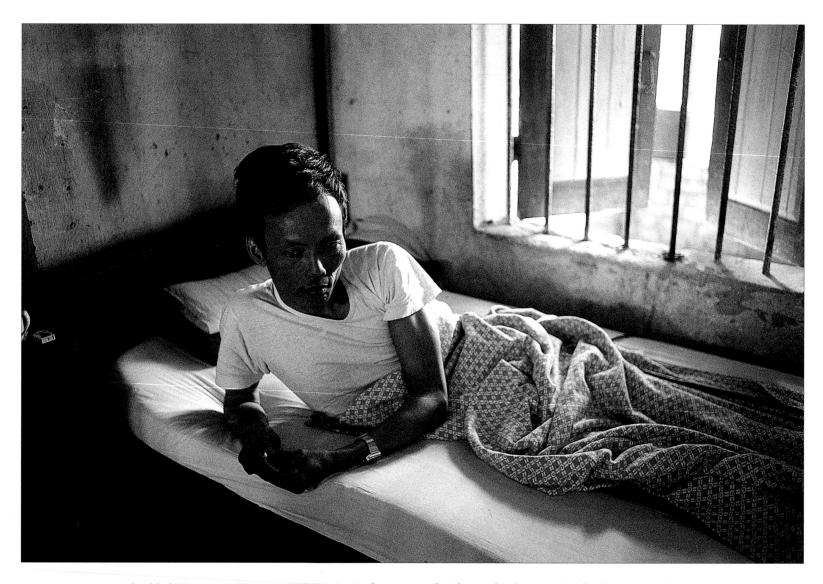

A disabled Vietnamese War veteran lies in bed in his room at the Thuan Thanh Center for the Disabled in the town of the same name east of Hanoi. Disabled war veterans live with their families at the center and are fully integrated into the life of the town.

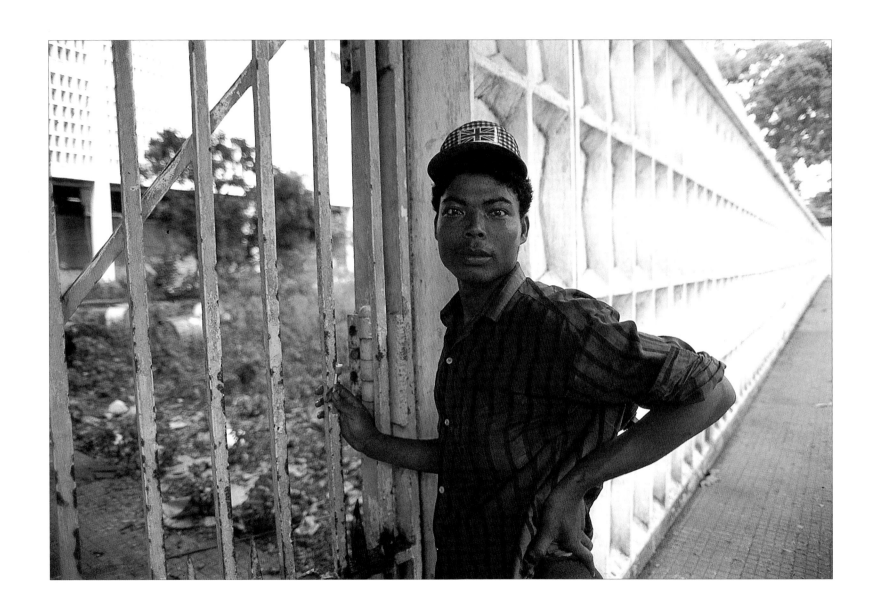

An Amerasian youth stands in front of the old U.S. Embassy in Ho Chi Minh City.

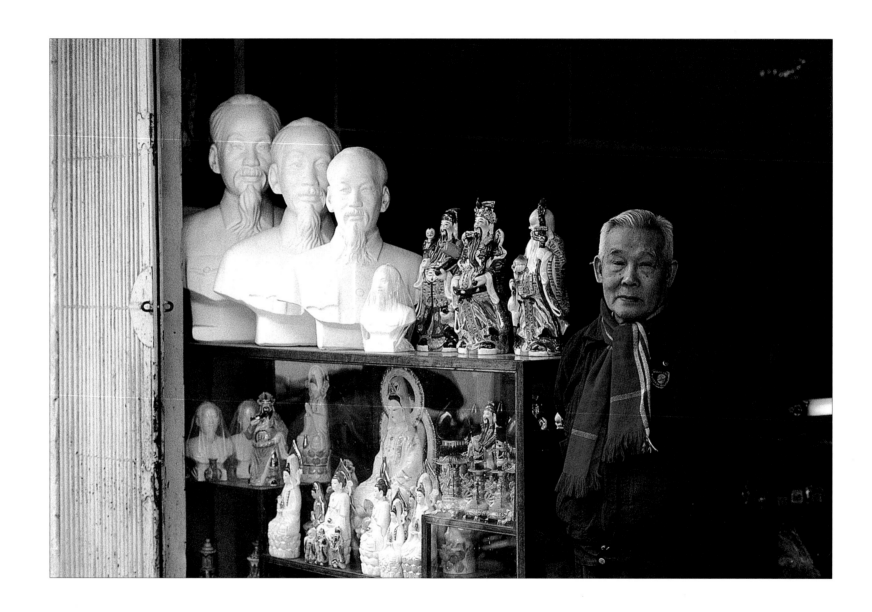

The secular and the religious merge as a shopkeeper offers both religious statues and busts of Ho Chi Minh. Hanoi.

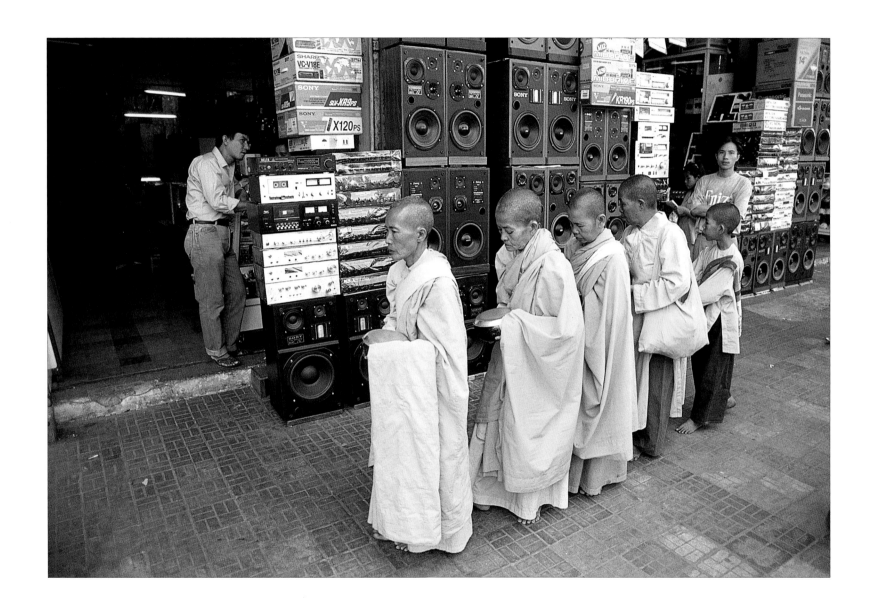

Buddhist monks begging for money as they walk down a sidewalk in downtown Ho Chi Minh City.

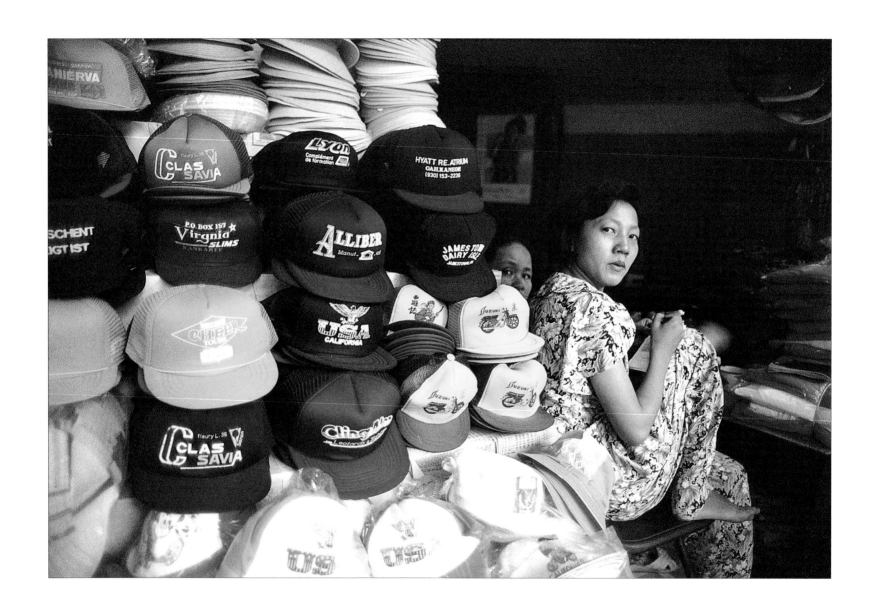

Hat shop. Hanoi.

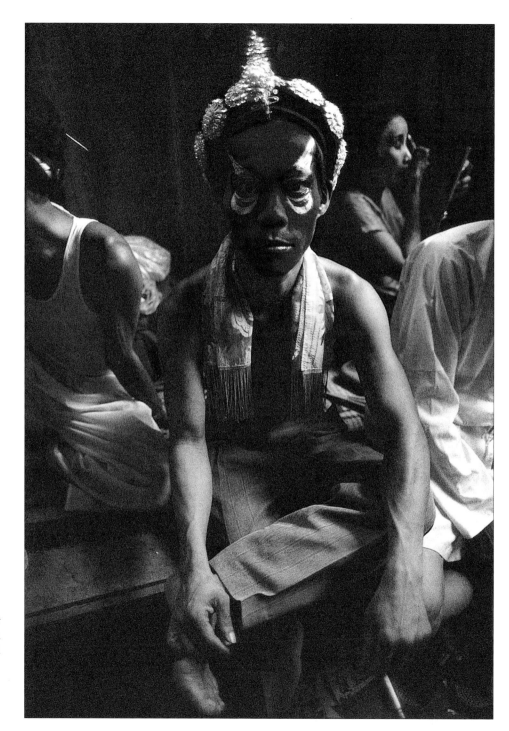

An actor waits backstage during a performance of *Hat Boi* at the Lang Ong Ba Chieu Temple in Ho Chi Minh City. *Hat Boi*, known as *Hat Tuong* in the North, is a form of classical theater based on Chinese opera.

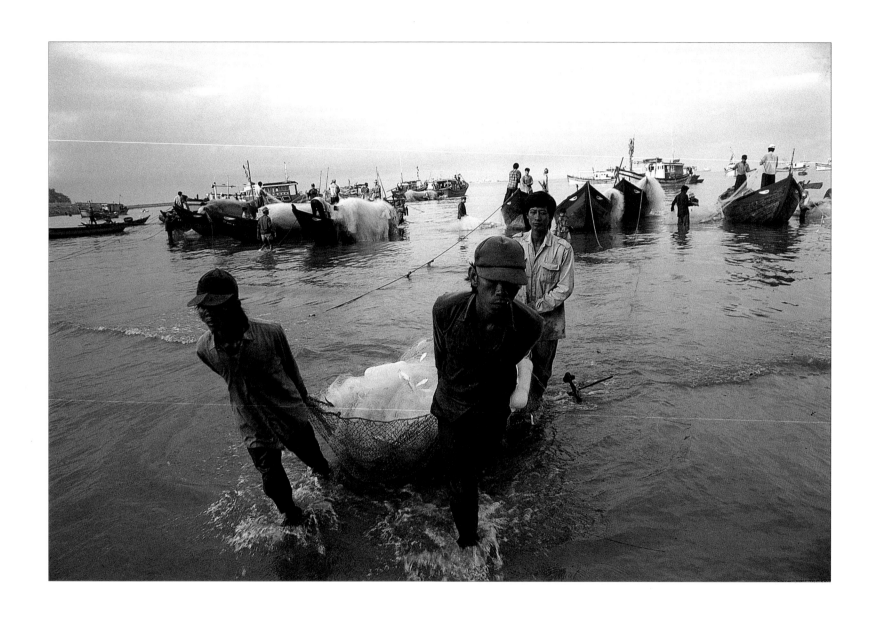

Fishermen bring in their catch. Vung Tau.

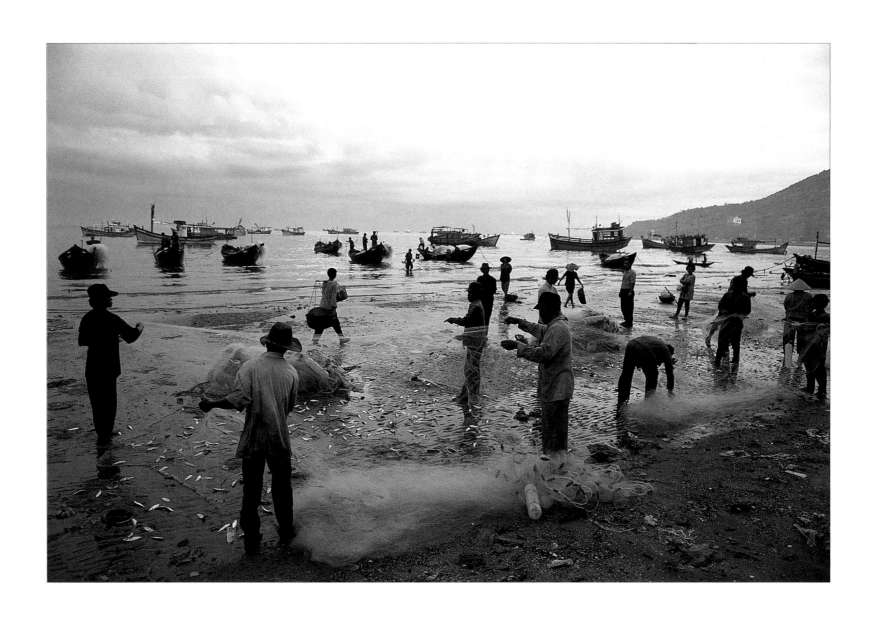

Sunrise on Front Beach. Vung Tau.

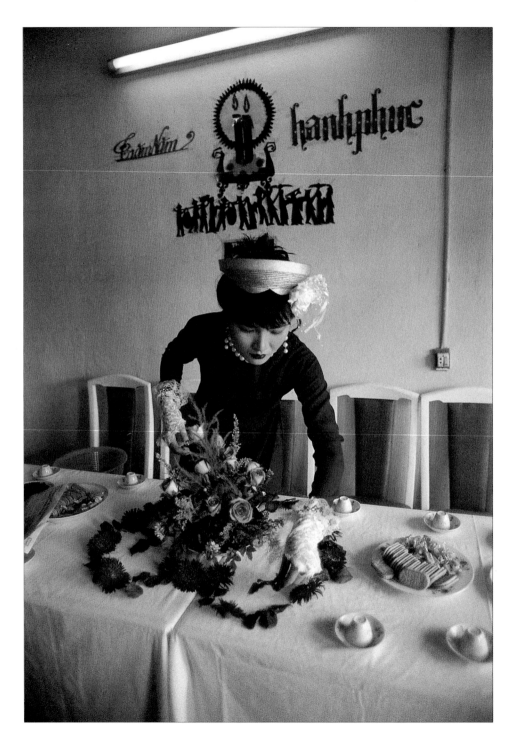

Wearing a traditional *ao dai*, a bride sets the table before her wedding ceremony. The wall behind her reads: "100 Years of Happiness." Ho Chi Minh City.

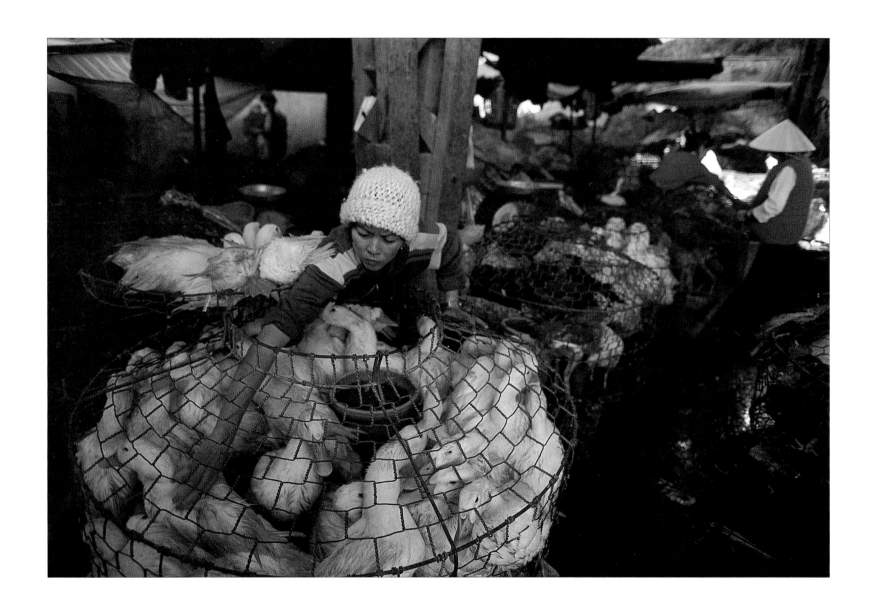

Vendor at the duck and chicken market. Dalat.

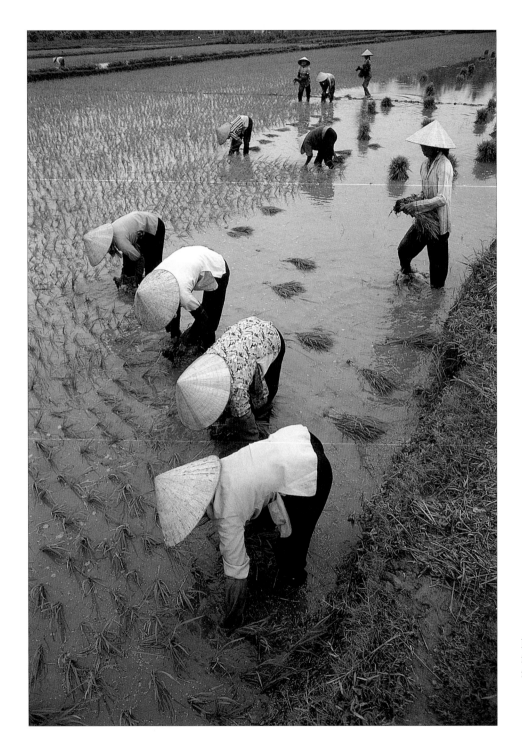

Farmers transplant rice seedlings in even-spaced rows, giving the seedlings adequate space to grow to maturity. Mekong Delta.

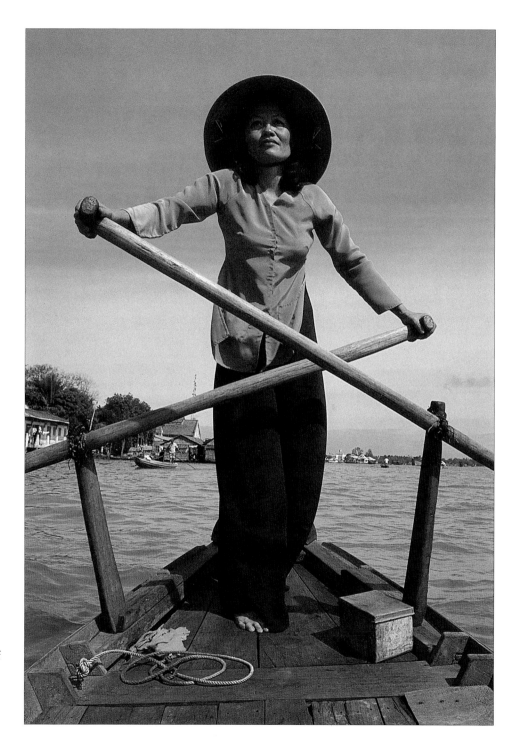

Woman rows down the Can Tho River near the city of
Can Tho in the Mekong Delta.

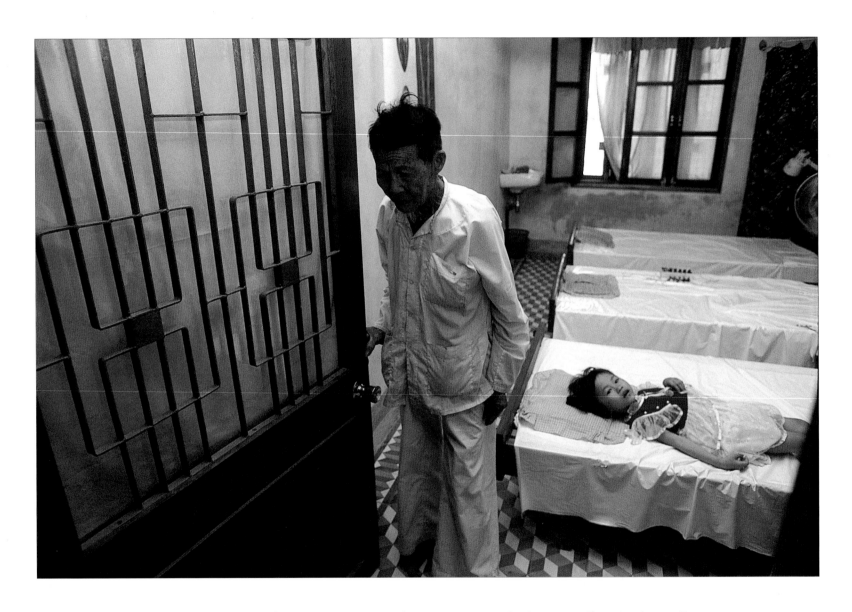

Old and young patients at the acupuncture clinic of the Peace Village Medical Center at China Beach, near Danang. The center is funded by the U.S.-based East Meets West Foundation.

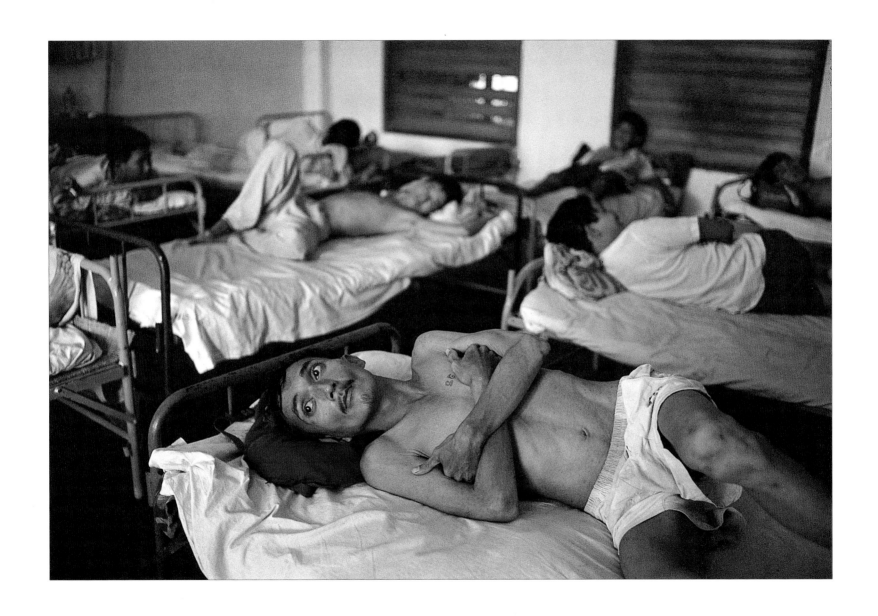

Addicts going through withdrawal at the Drug Abuse Tackling and Prevention Center. Ho Chi Minh City.

71

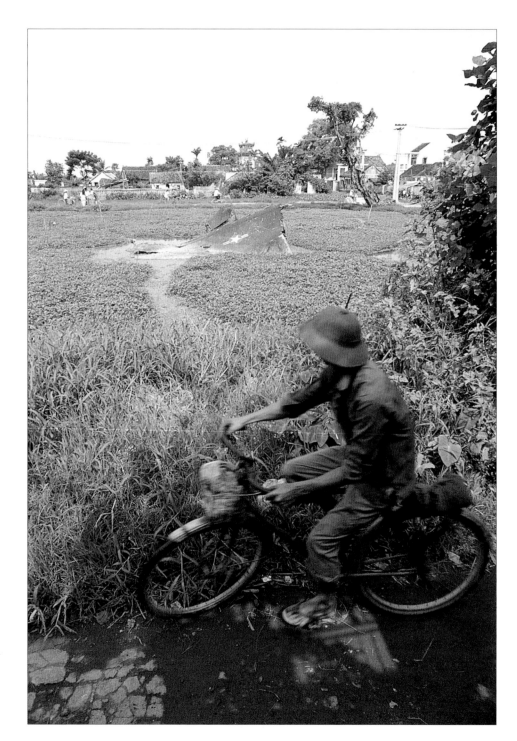

A cyclist rides past the wreckage of an American B-52 bomber shot down during the "Christmas Bombing" of 1972. Hanoi.

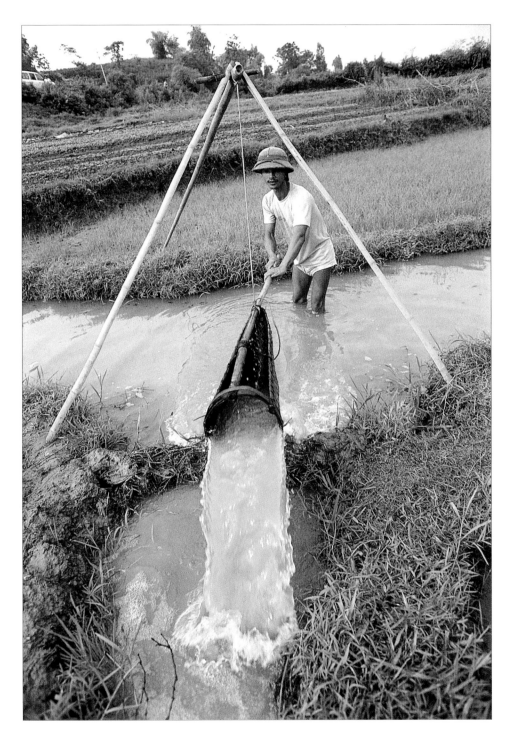

A farmer irrigates his rice paddy. Tuyen Quang Province.

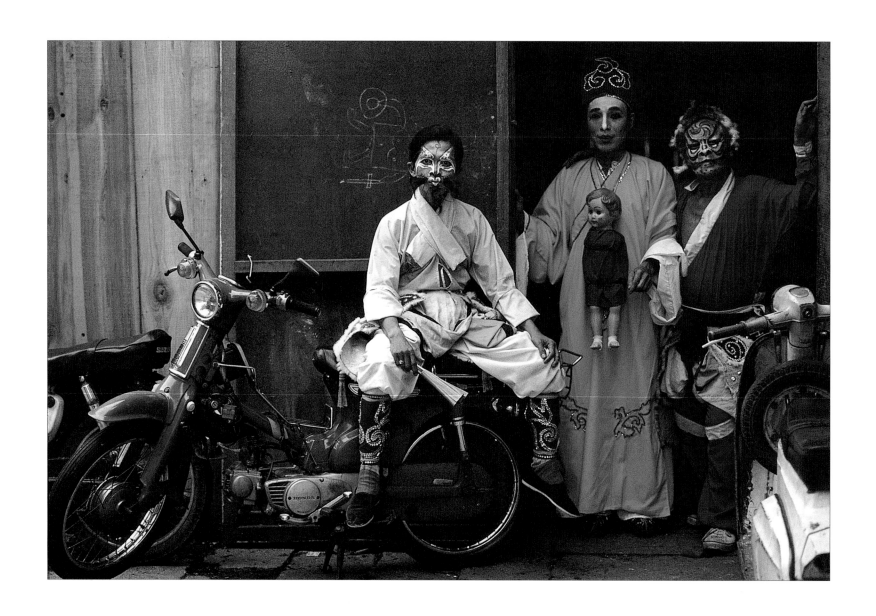

Hat Boi actors take a break out back during a performance at a temple in Ho Chi Minh City.

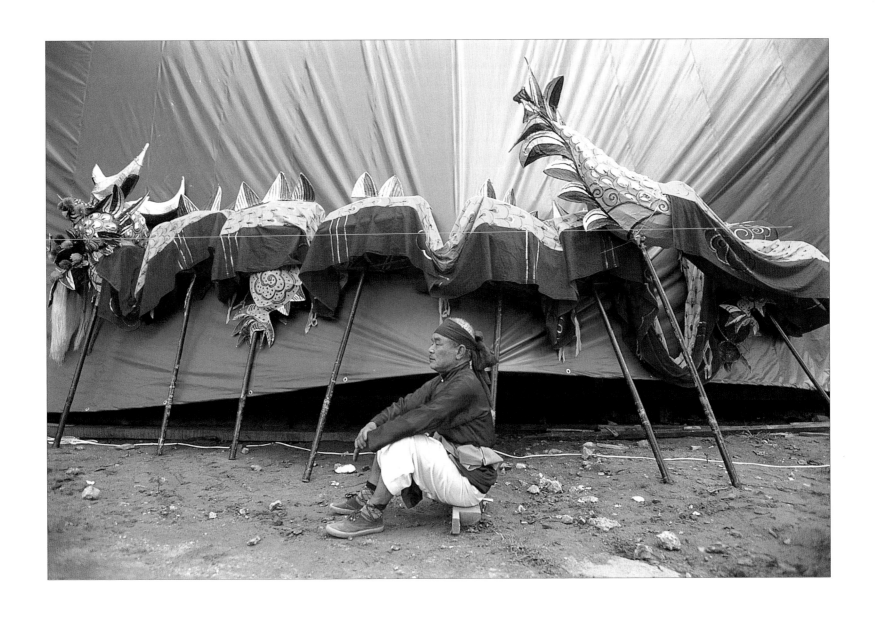

A performer waits for the start of the Dragon Dance. Hanoi.

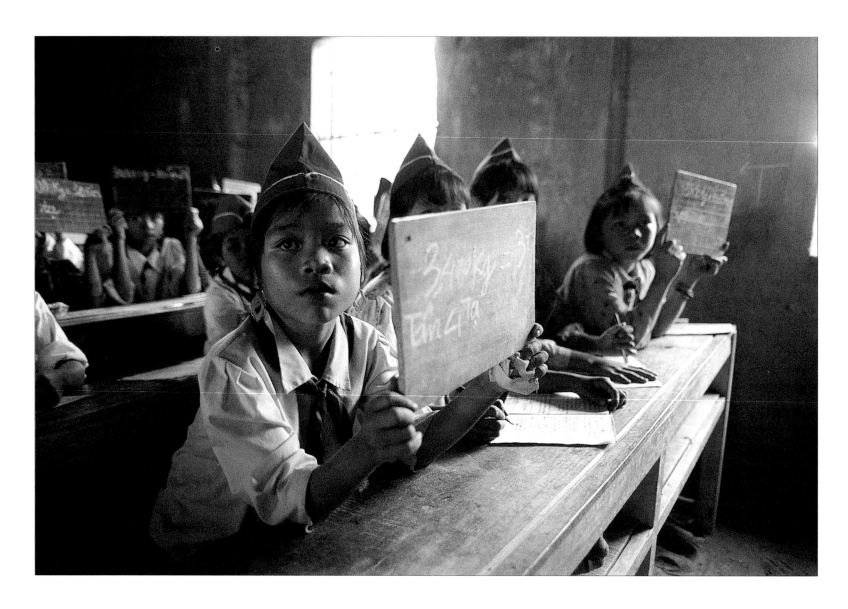

Schoolchildren hold up chalkboards with their answers to a math question during class at the Sen Thuy Elementary School near Dong Hoi in Quang Binh Province.

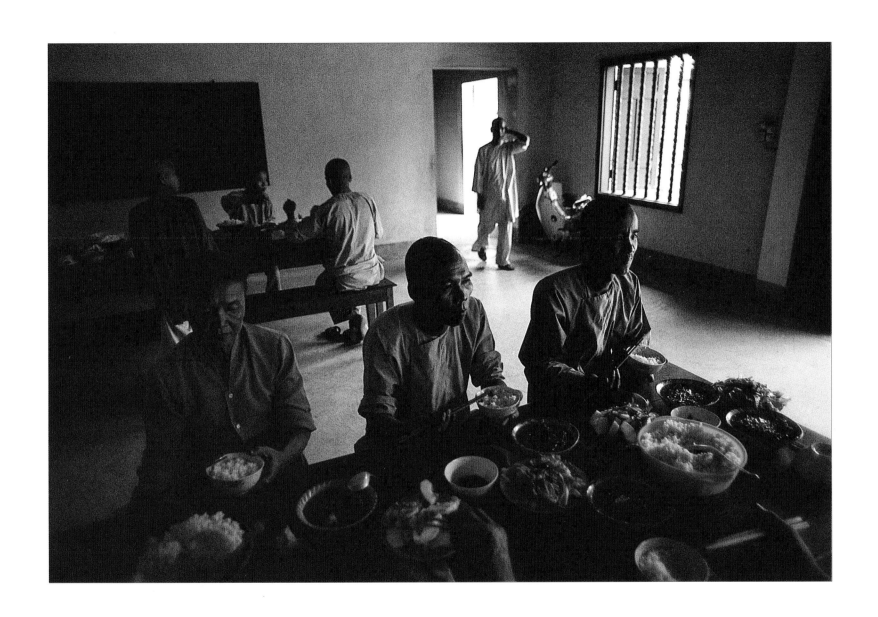

Buddhist monks and workers eat their communal lunch at the Thien Mu Pagoda. Hue.

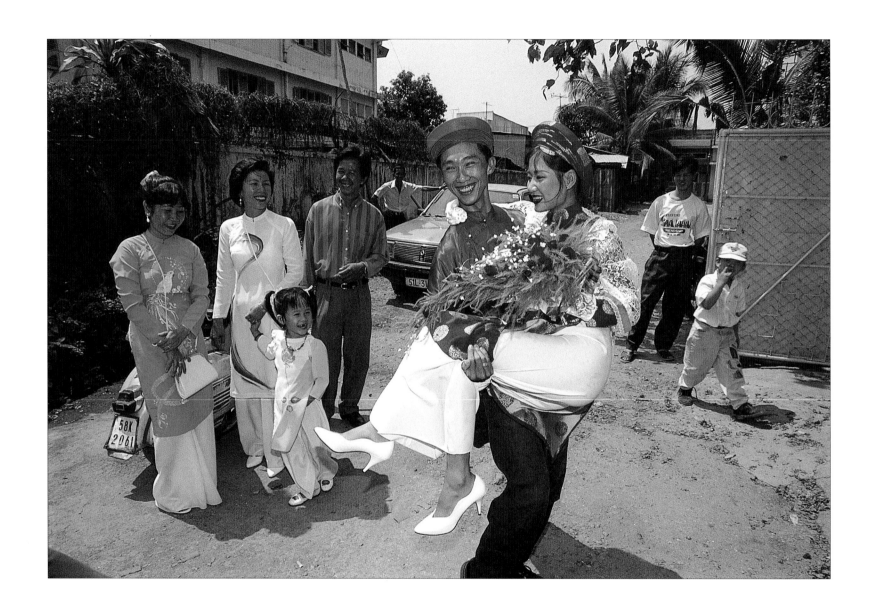

Bride and groom after their wedding ceremony. Ho Chi Minh City.

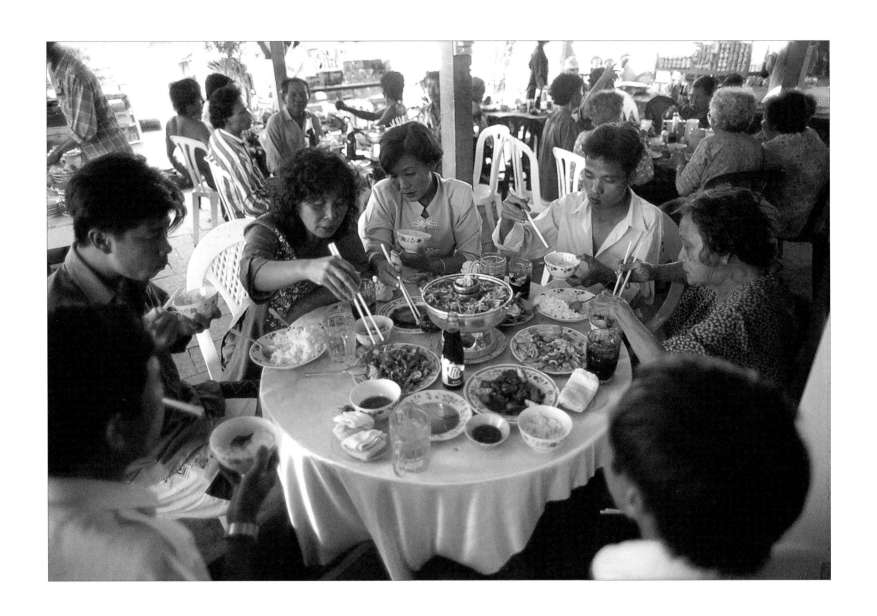

Travelers eat at a roadside restaurant. Phan Thiet.

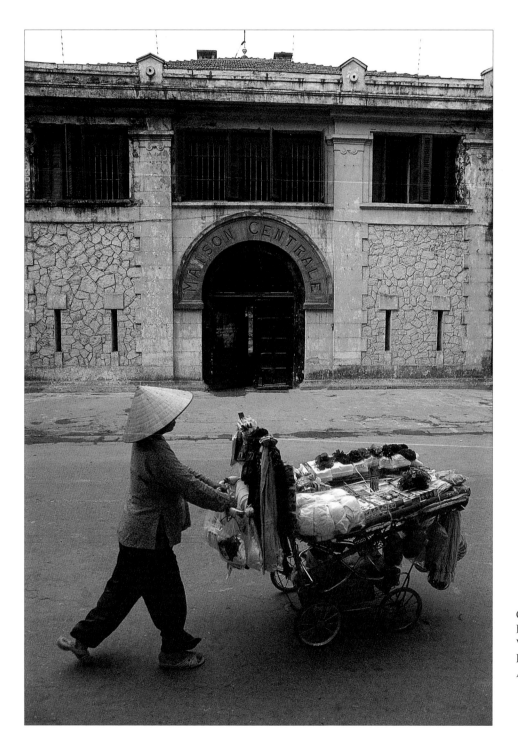

Constructed in the early twentieth century by the French, the Hoa Lo Prison in Hanoi was used to jail Vietnamese revolutionaries. Nicknamed the "Hanoi Hilton" by U.S. POWs who were held there during the American War, it is now a museum.

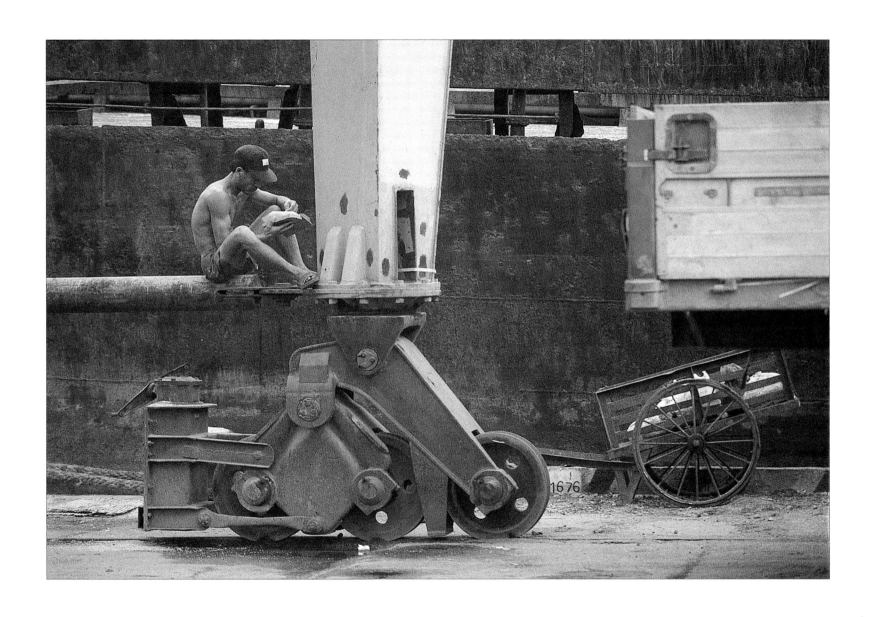

A worker on break reads while sitting on the base of a huge cargo crane at Haiphong Port.

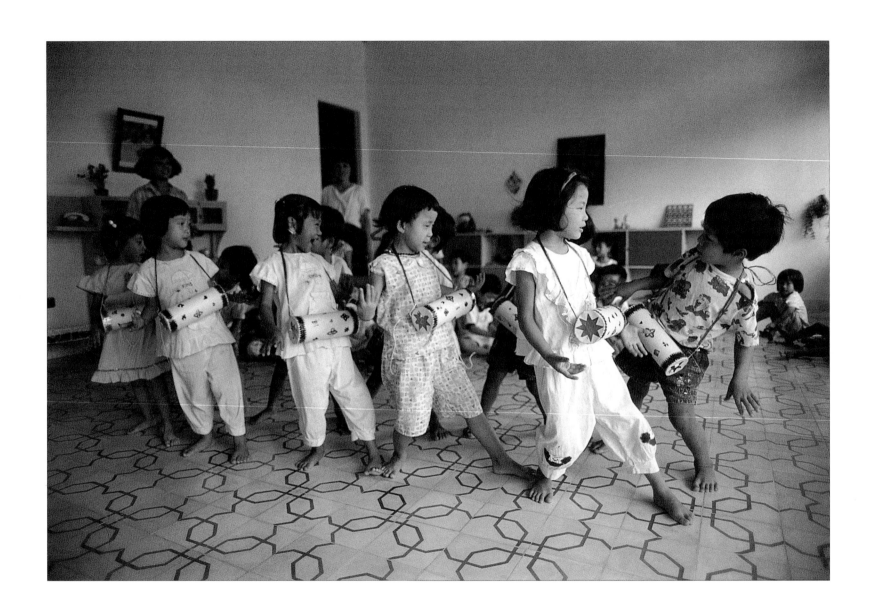

Children dance at the SOS-Children's Village, which cares for orphaned and abandoned children. Hanoi.

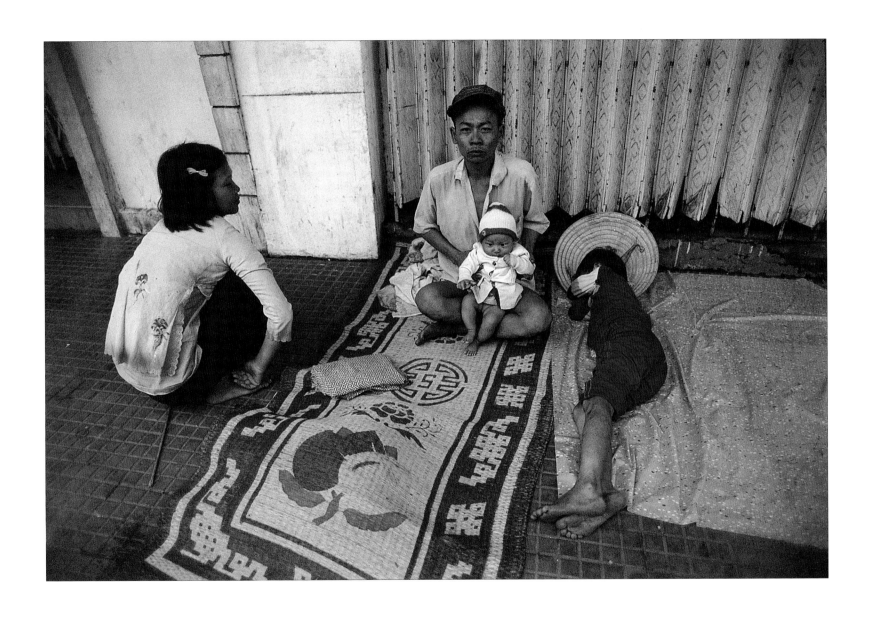

Family living on the street in downtown Ho Chi Minh City.

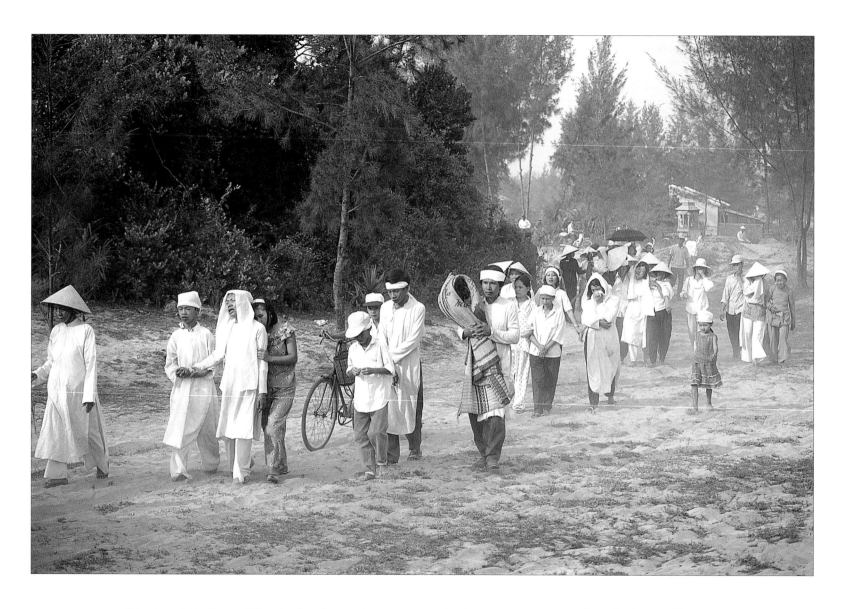

Wearing white, the traditional color of mourning, members of a funeral procession march to the deceased's grave site. Hoi An.

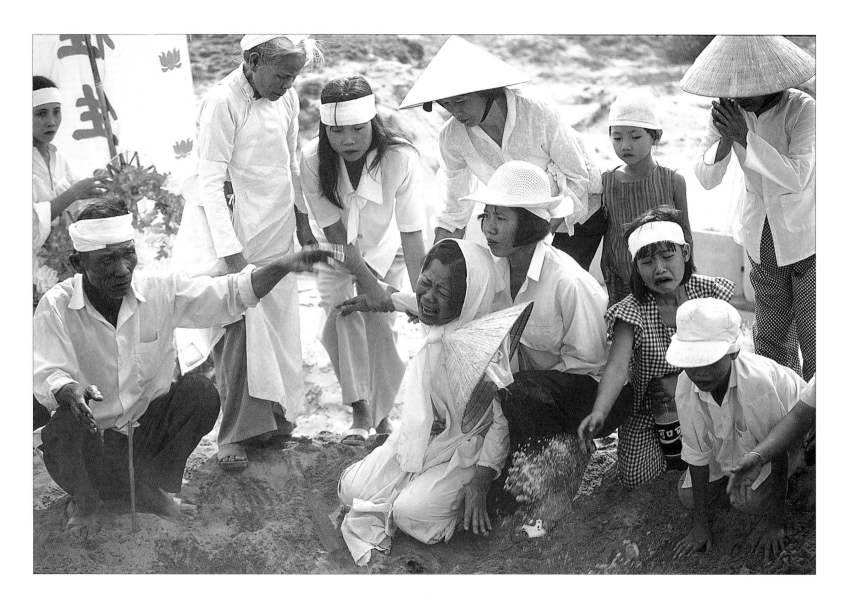

Overcome by grief during her mother's funeral, a woman is helped by family members after collapsing by the grave. Hoi An.

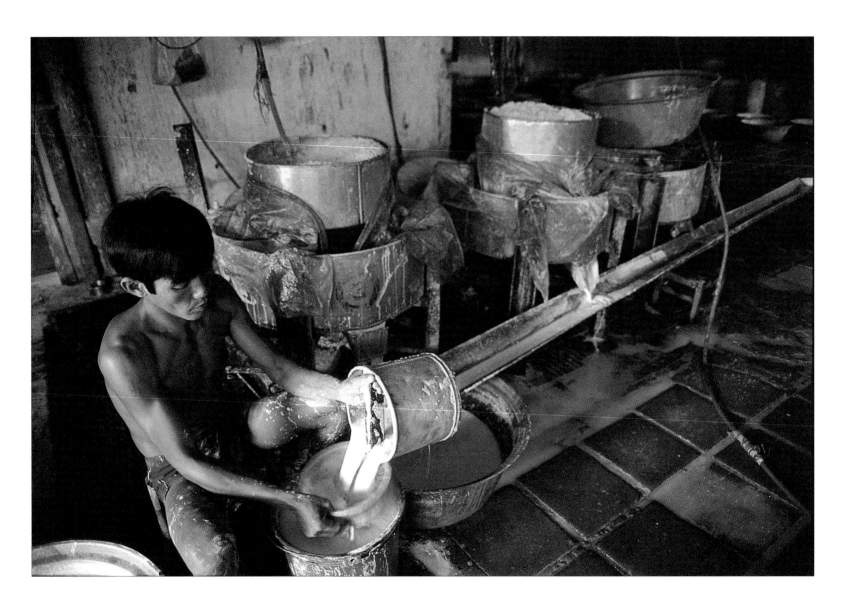

A patient makes rice paper at the Drug Tackling and Prevention Center. The center uses physical therapy and hard work to help rehabilitate addicts. Ho Chi Minh City.

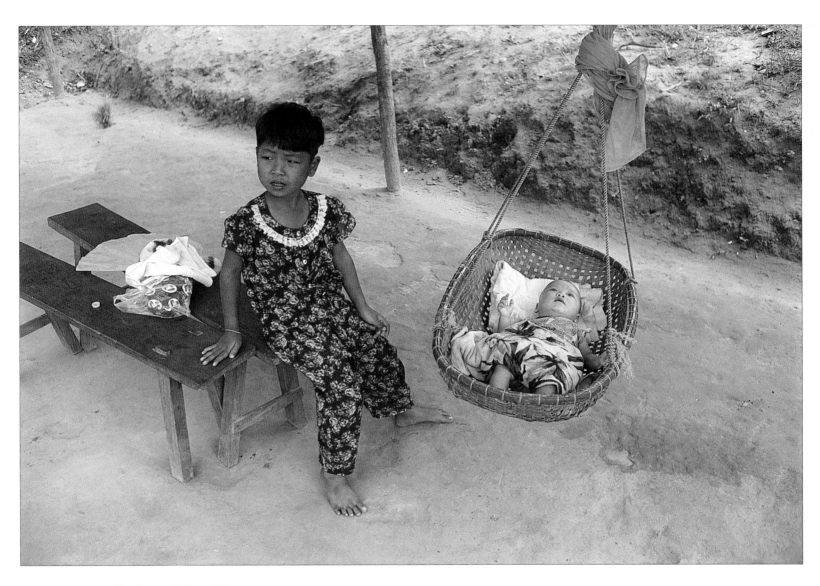

Brother and sister. Hue.

Overleaf: Farmer walks across the abandoned airstrip at the former U.S. Marine Combat Base at Khe Sanh.

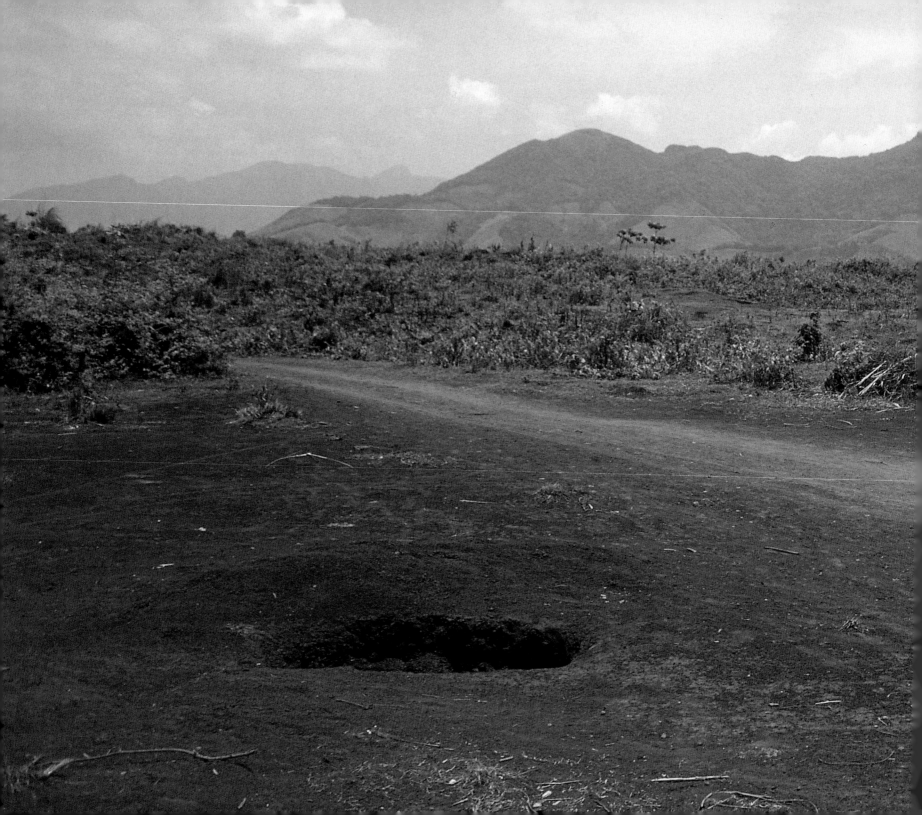

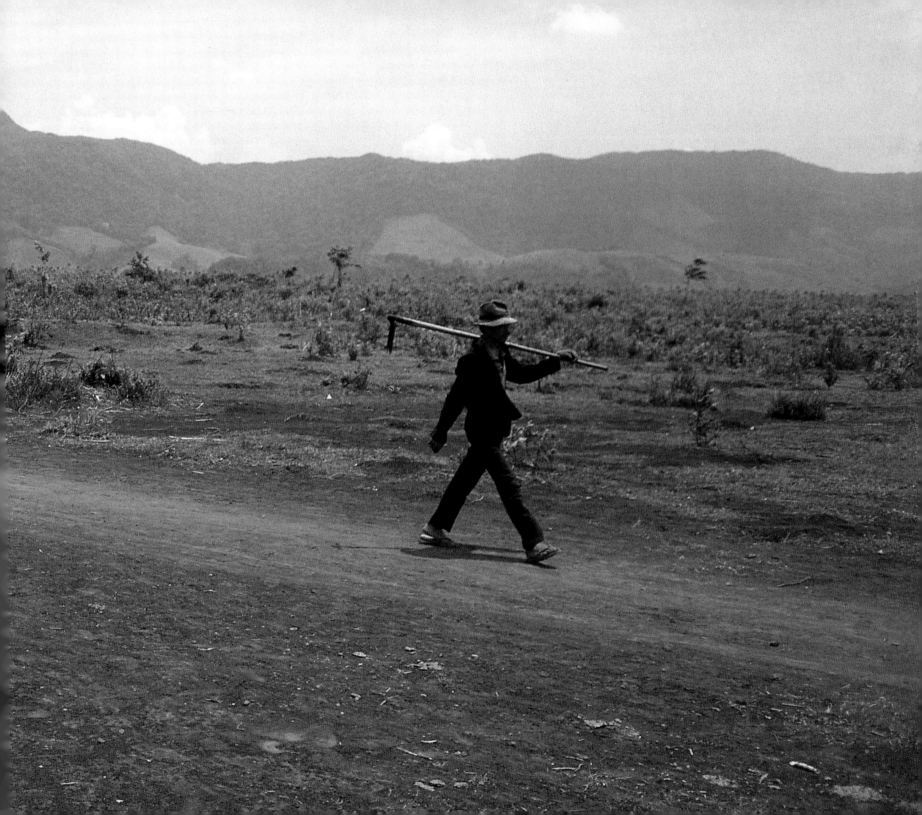

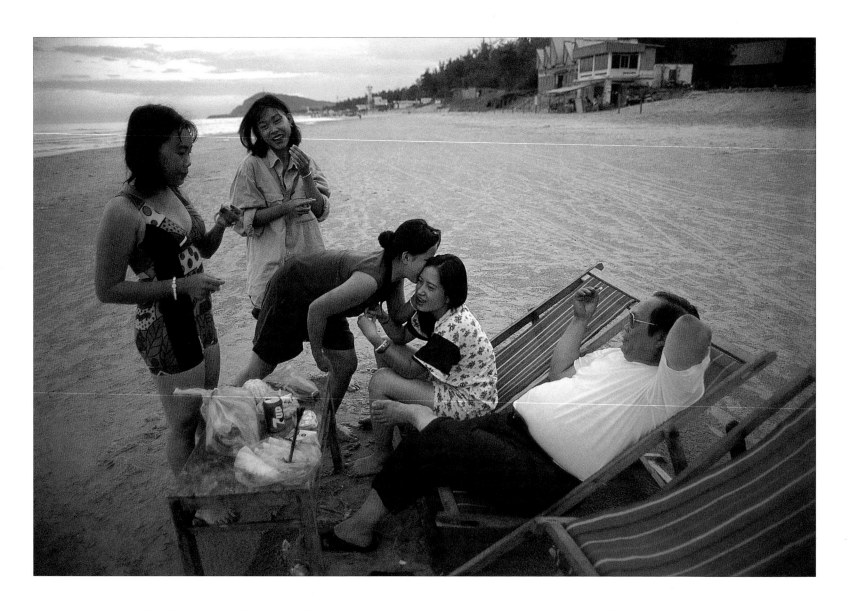

A *Viet Kieu*, overseas Vietnamese, from the United States relaxes on the beach with some of his family members. Vung Tau.

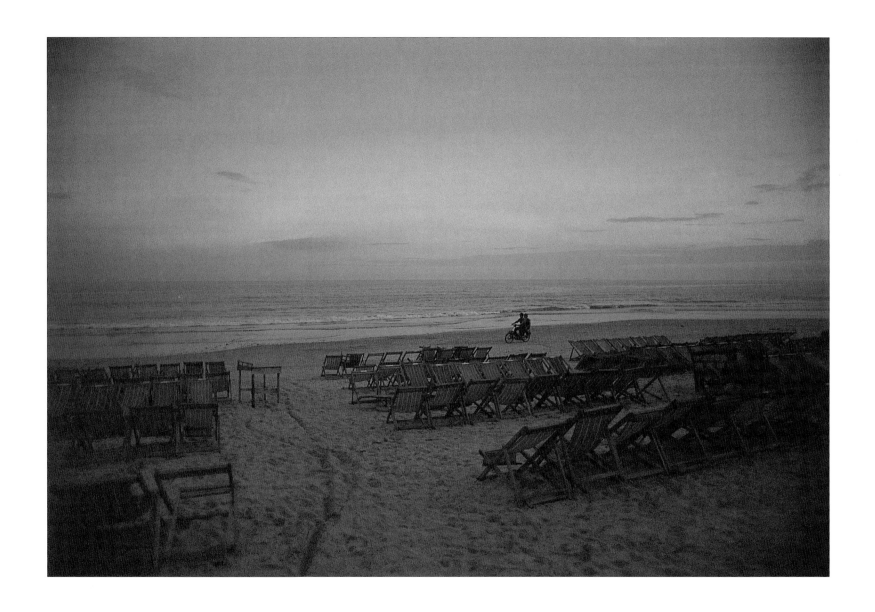

Sunset. Vung Tau.

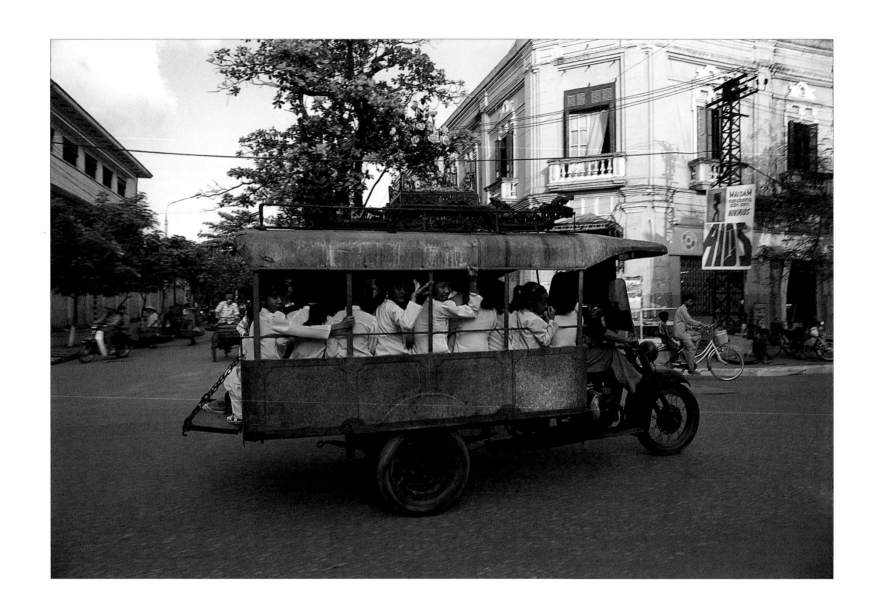

Downtown Haiphong.

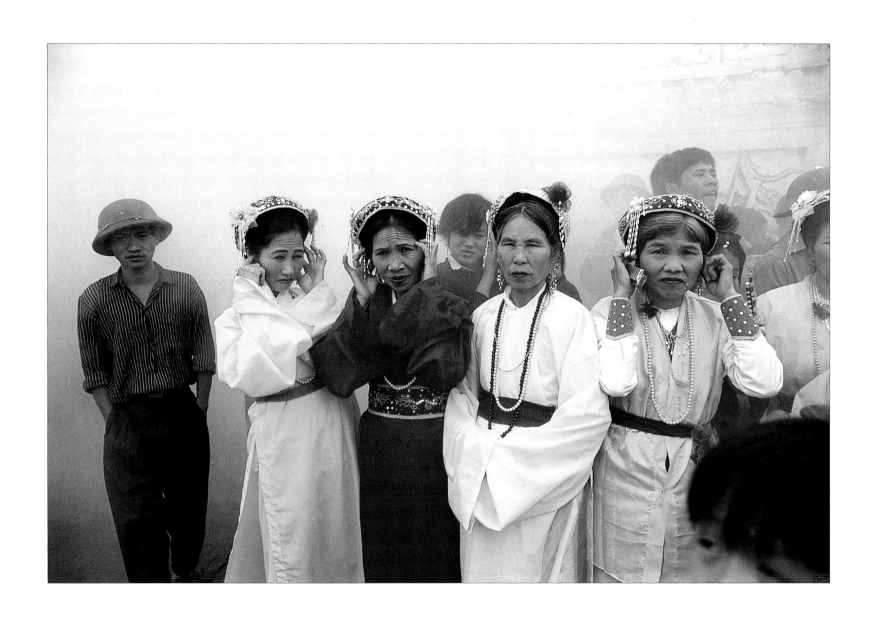

Firecrackers during a festival honoring tenth-century Vietnamese military heroes at Co Dien village near Hanoi.

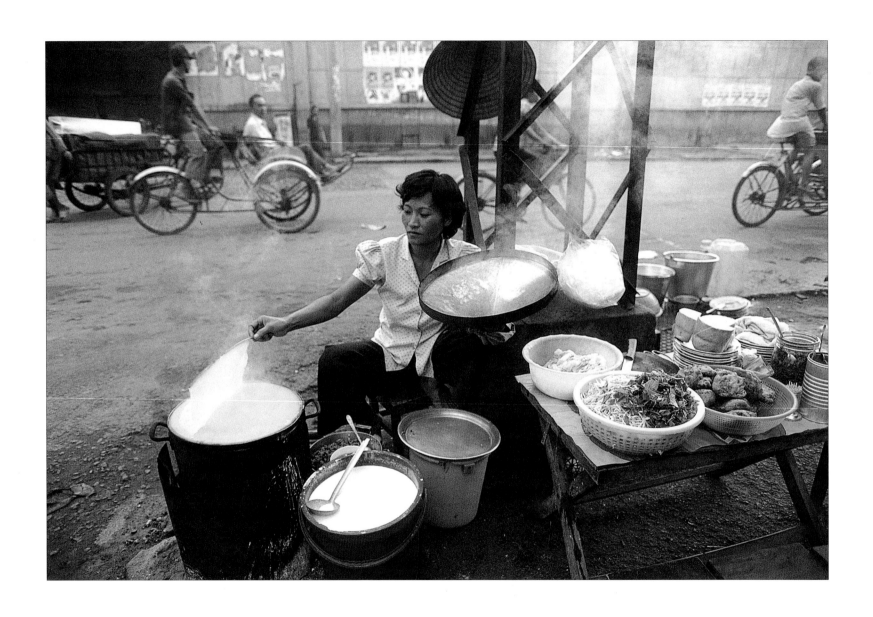

A street vendor cooks *banh cuon*, steamed rice-flour pancakes. Ho Chi Minh City.

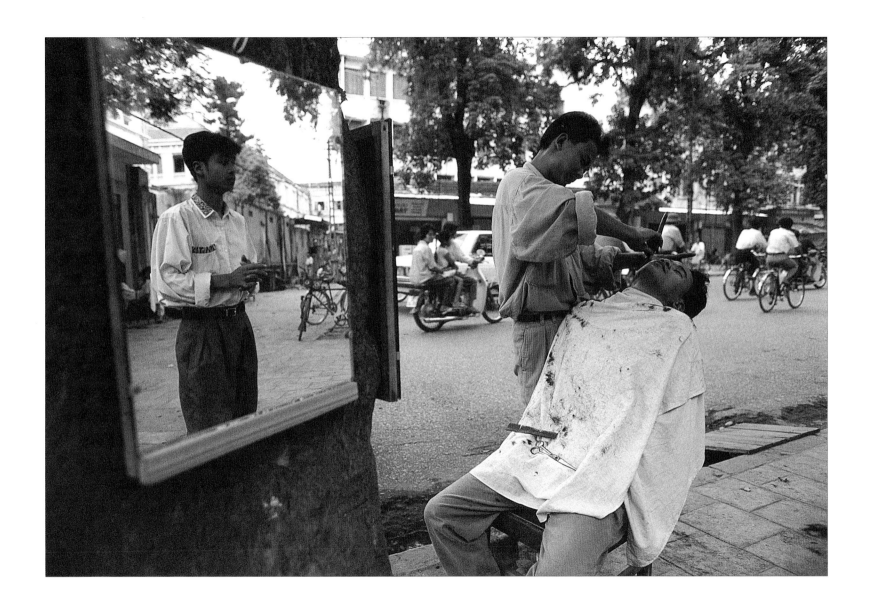

Street-side barber. Hanoi.

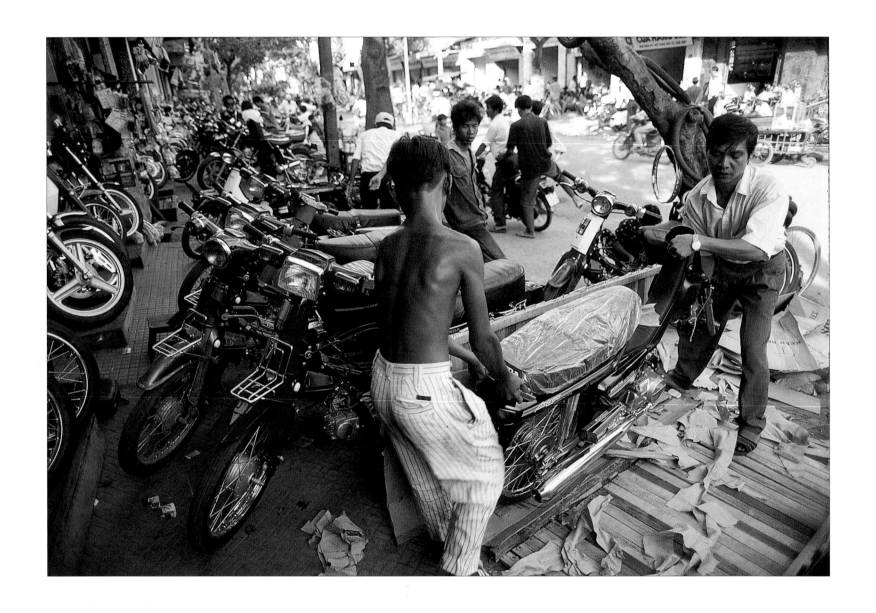

Newly imported Honda motorbikes. Ho Chi Minh City.

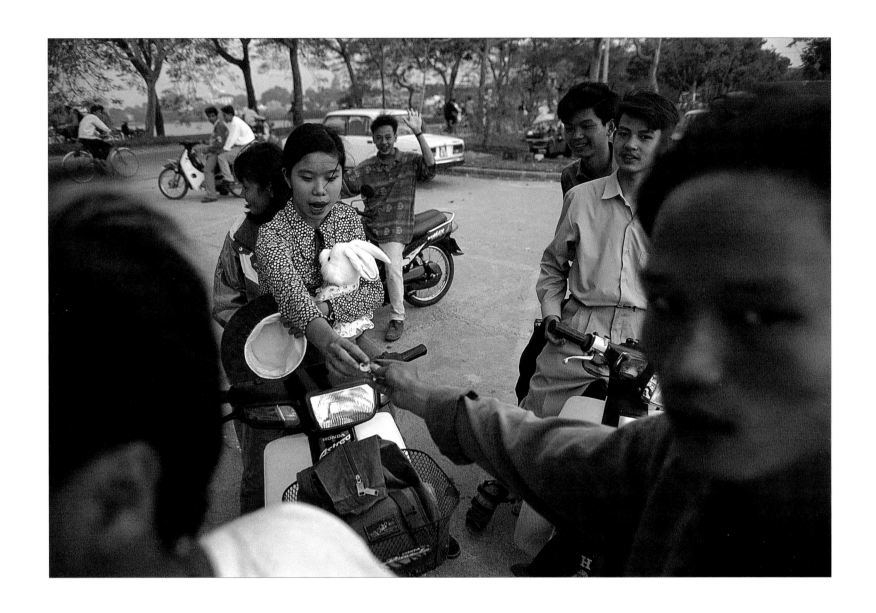

Youth hanging out on Thanh Nien (Youth) Road. Hanoi.

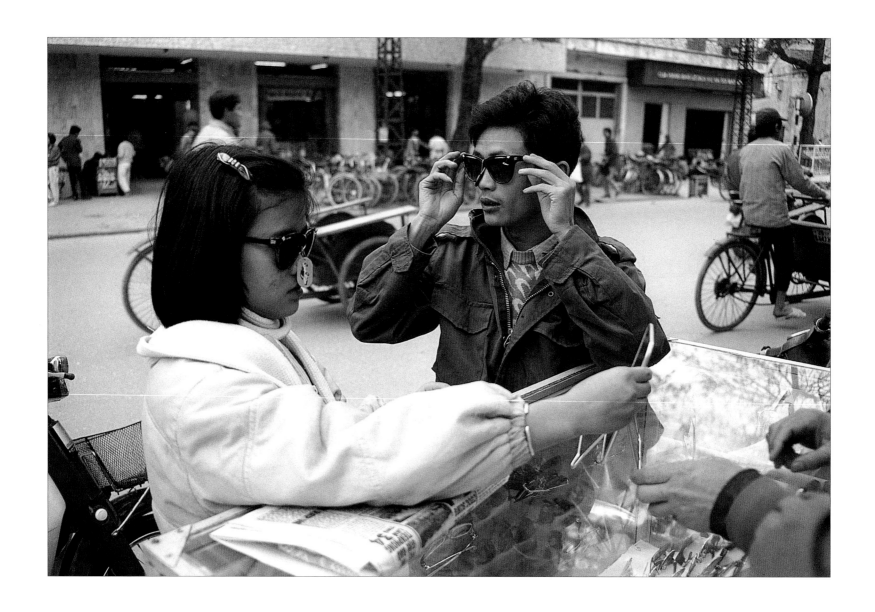

Customers try out new sunglasses. Hanoi.

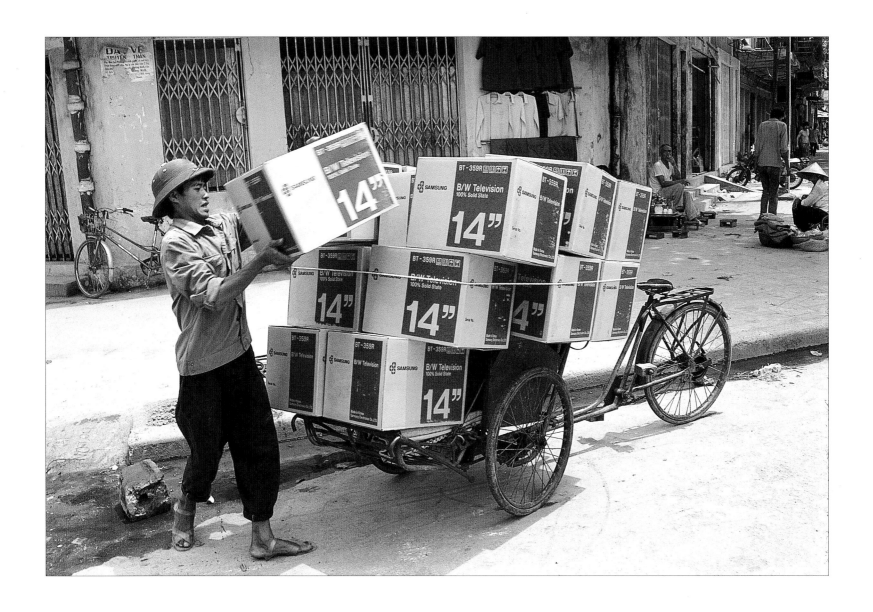

Newly imported black-and-white television sets. Hanoi.

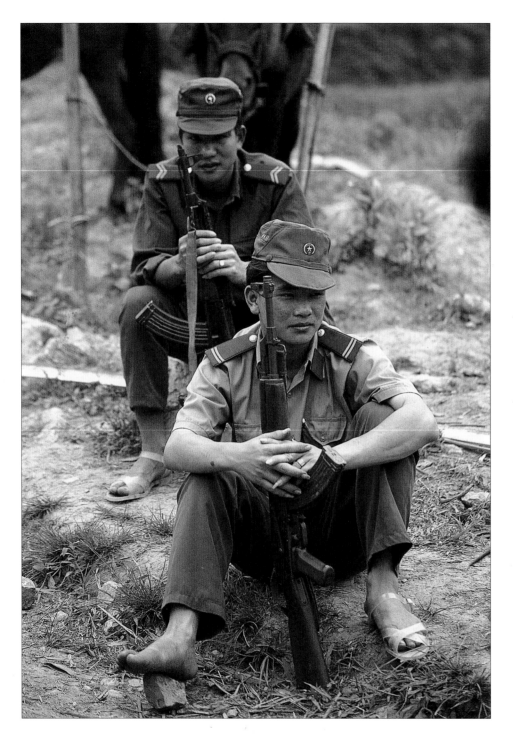

Two Vietnamese soldiers on duty on market day at the village of Can Cau in Lao Cai Province. This area near the Chinese border was the scene of heavy fighting during the 1979 war between Viet Nam and China.

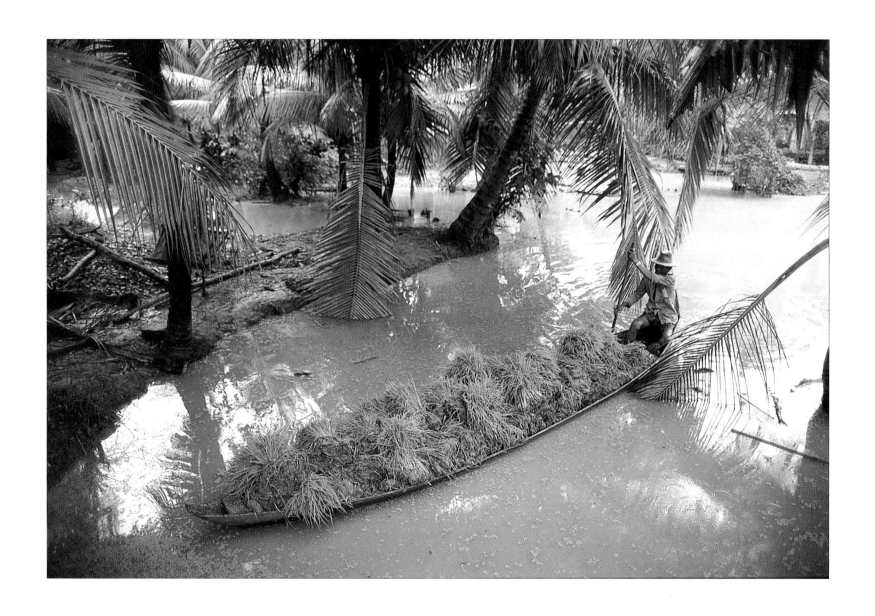

A farmer transports rice seedlings down a small canal to replant them in his paddies. Mekong Delta.

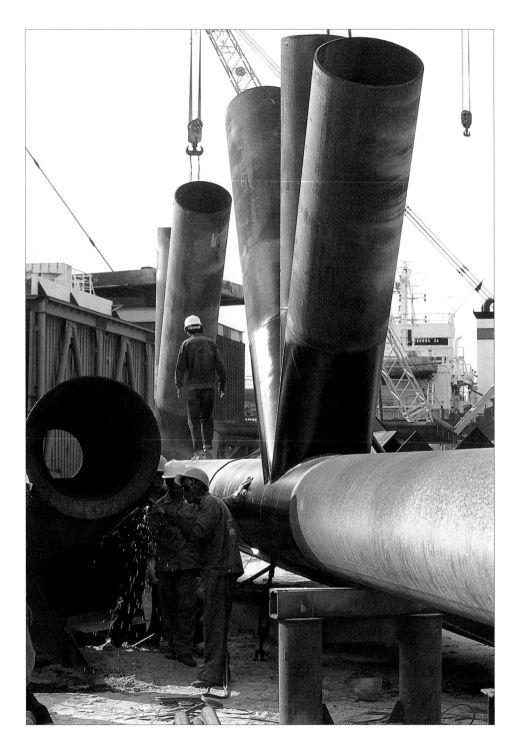

Vietnamese workers construct a component of an off-shore oil platform at the Vietsovpetro construction and port facility in Vung Tau. Vietsovpetro is a Russian-Vietnamese joint venture oil company currently producing oil from wells some 75 miles off-shore of Vung Tau.

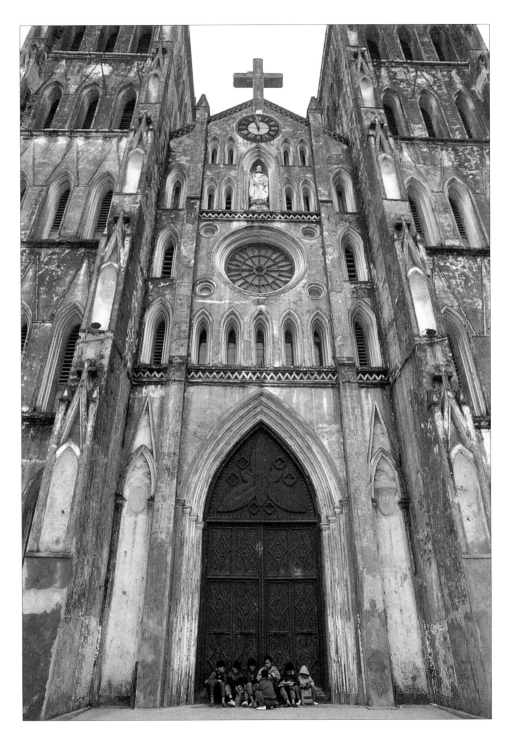

Schoolchildren in front of St. Joseph's Catholic Cathedral, which was built by the French and inaugurated in 1886. Hanoi.

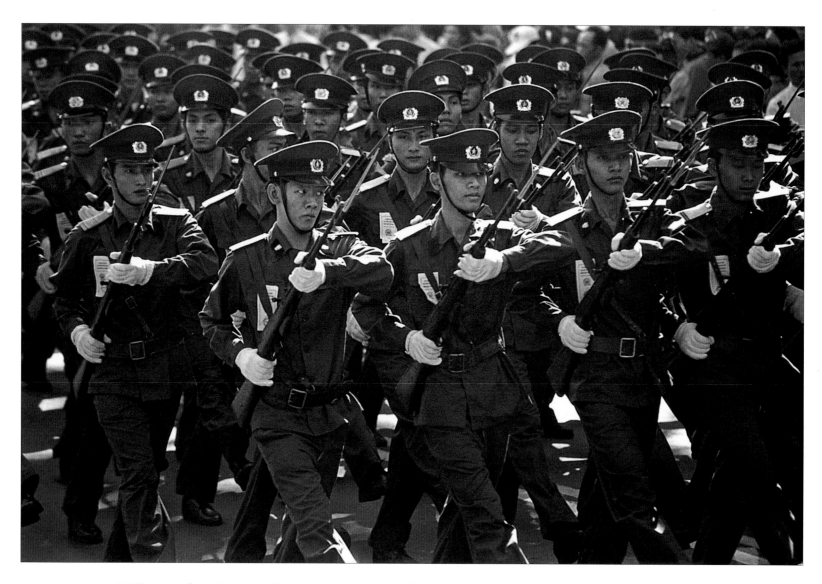

Soldiers march in formation during a parade in Ho Chi Minh City marking the twentieth anniversary of the Liberation of Saigon. Saigon, since renamed Ho Chi Minh City, fell to North Vietnamese and National Liberation Front forces on April 30, 1975, marking the end of the Viet Nam War.

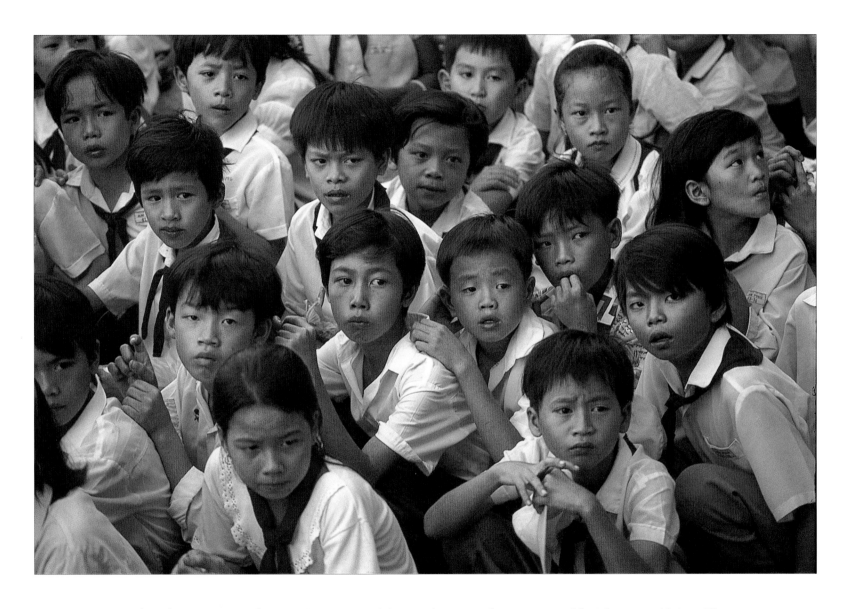

Schoolchildren wait for the start of a program celebrating the twentieth anniversary of the Liberation of Saigon. Ho Chi Minh City.

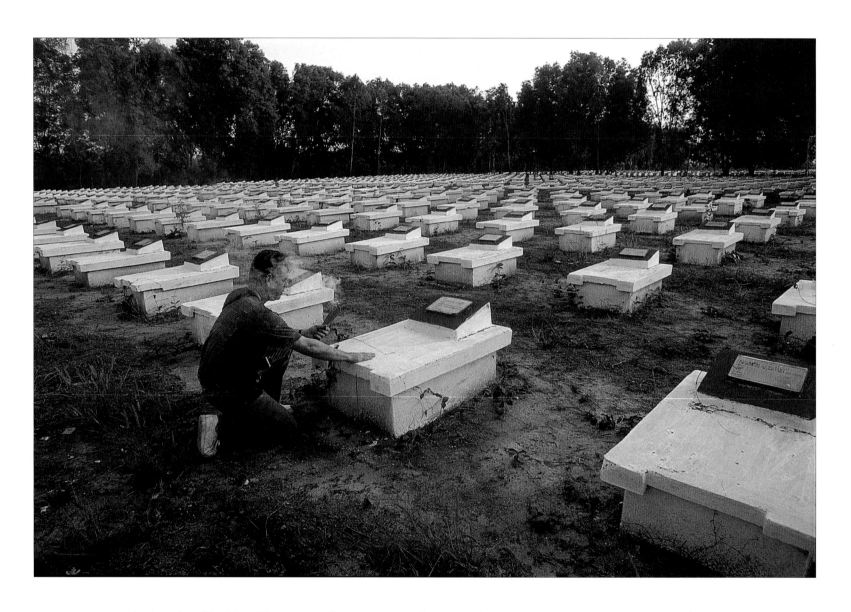

An American Viet Nam War veteran places incense on the grave of a National Liberation Front soldier at the Cu Chi Cemetery for War Martyrs.

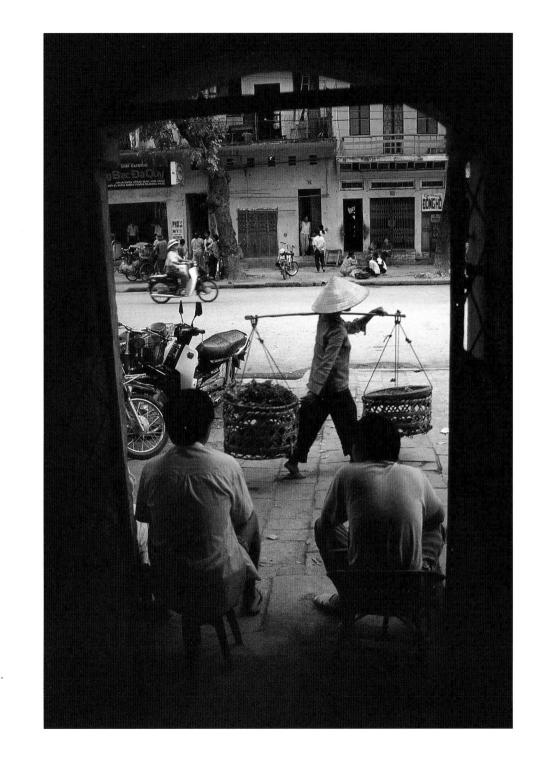

Looking from an alleyway onto Hue Street. Hanoi.

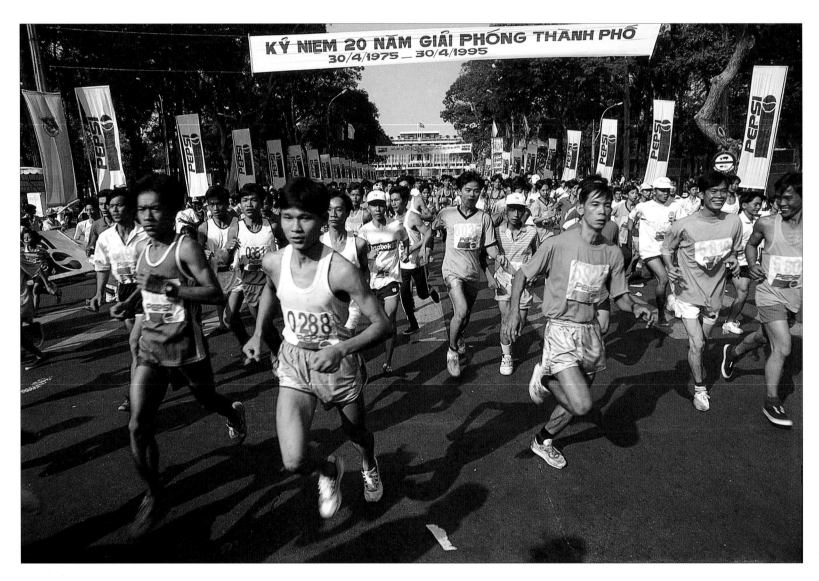

Runners make their way down Le Duan Boulevard at the start of the 1995 Ho Chi Minh City Marathon sponsored by Pepsi-Cola. At the end of the street, in the rear, is the old South Vietnamese Presidential Palace, now known as Reunification Hall. Ho Chi Minh City.

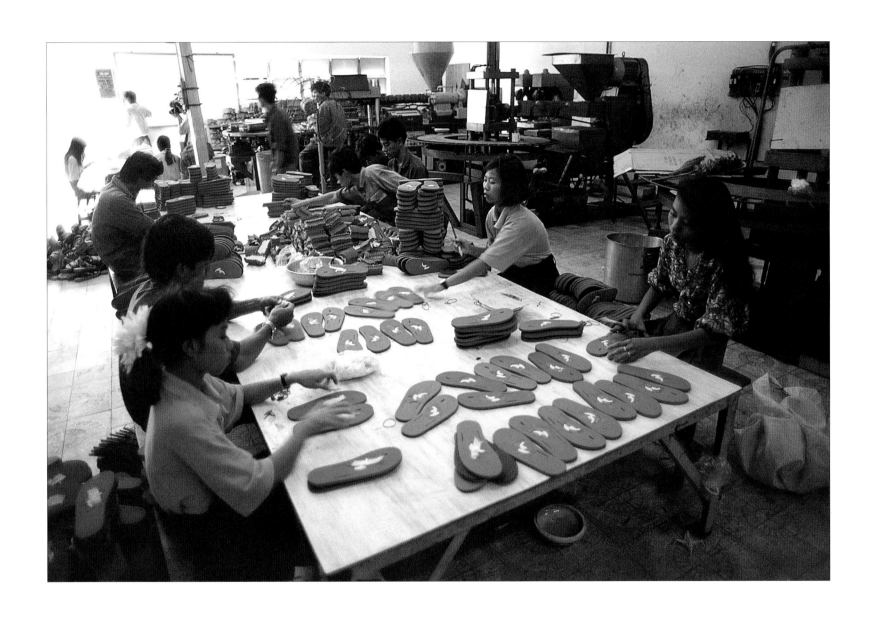

Workers at the *biti's* shoe factory, one of the largest private businesses in Viet Nam. Ho Chi Minh City.

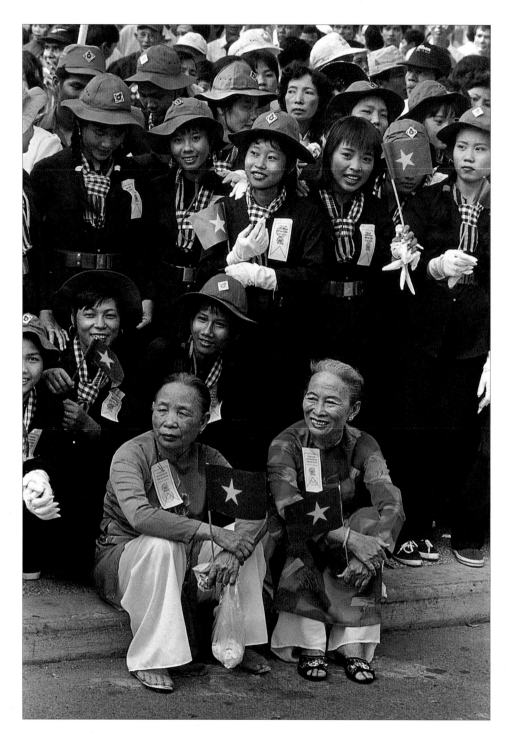

Two women wearing traditional *ao dai* sit beneath a contingent of young women wearing the uniforms of National Liberation Front (Viet Cong). They are watching a parade celebrating the twentieth anniversary of the Liberation of Saigon. Ho Chi Minh City.

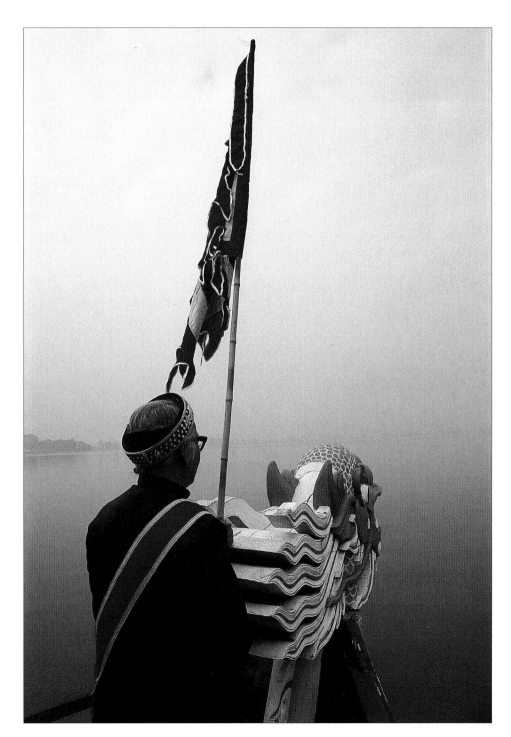

A dragon boat carrying religious pilgrims floats across
fog-shrouded Ho Tay (West Lake) in Hanoi. Many his-
toric pagodas and temples line the shore of Ho Tay.

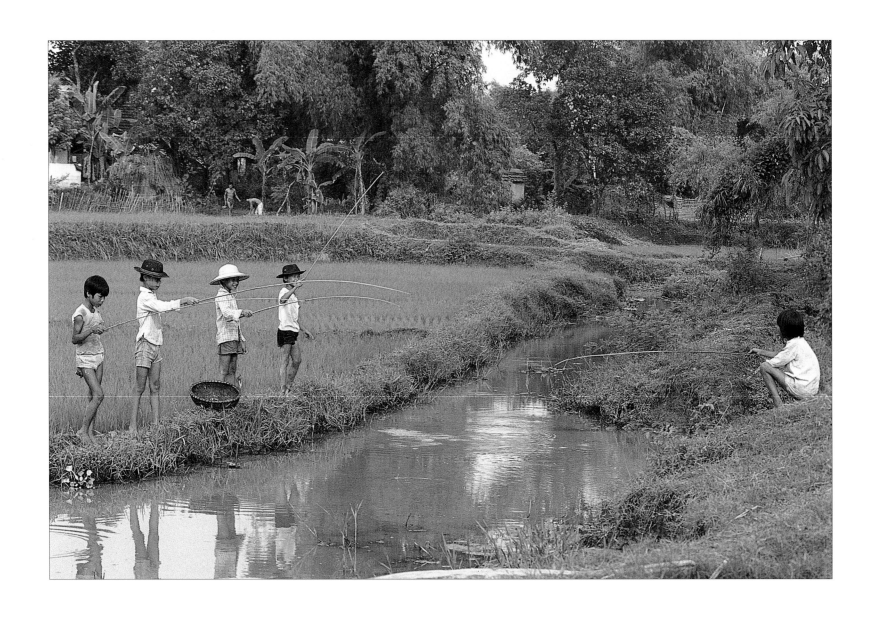

Boys fish in an irrigation canal. Tuyen Quang Province.

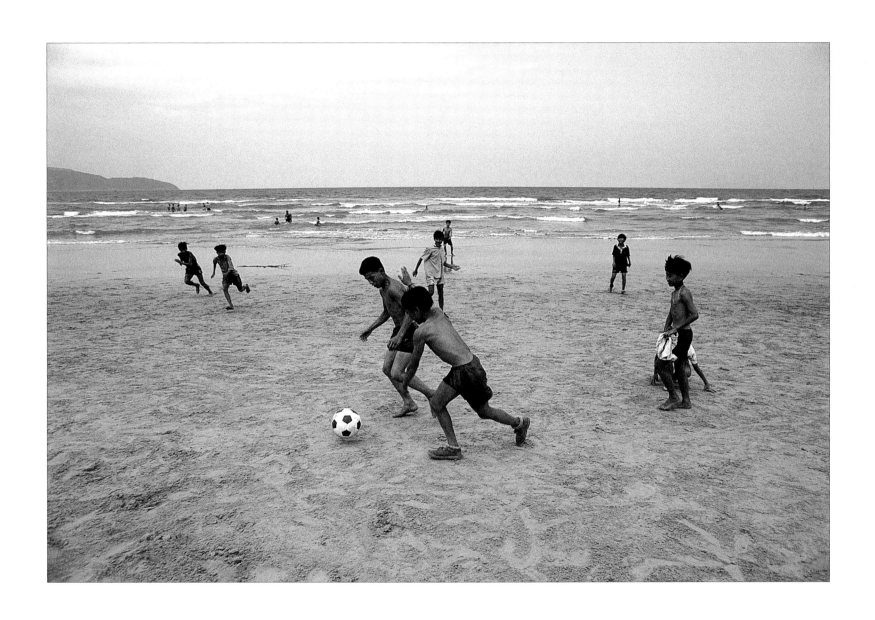

Soccer game on My Khe Beach. Danang.

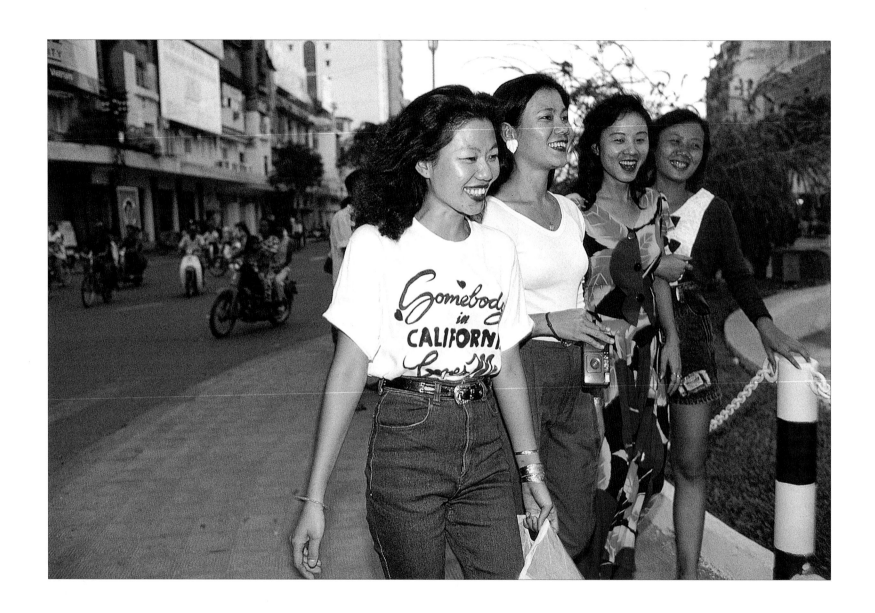

Young women in downtown Ho Chi Minh City.

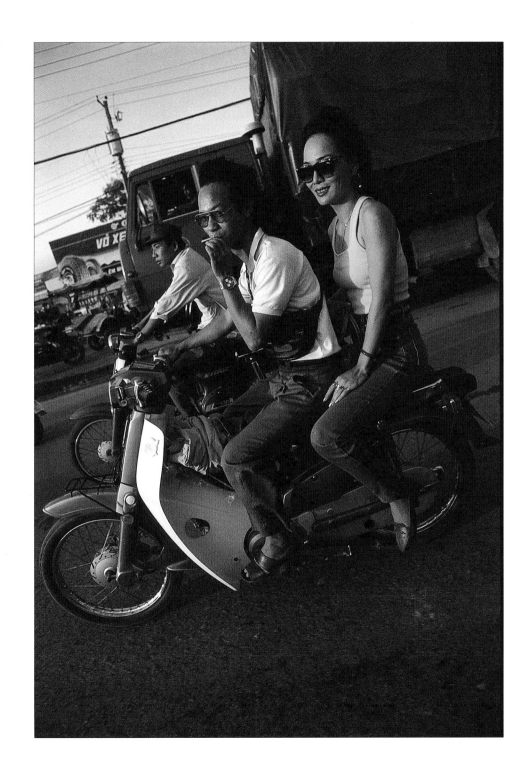

Bikers on Dien Bien Phu Street. Ho Chi Minh City.

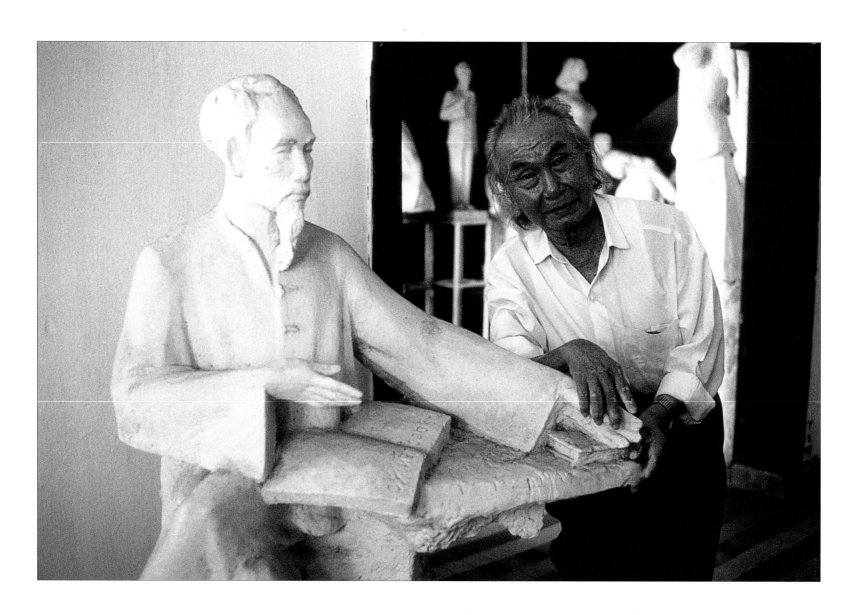

Nationally renowned sculptor Diep Minh Chau with one of his sculptures of Ho Chi Minh in his studio in Ho Chi Minh City. A revolutionary fighter-turned-artist, Chau's monumental statuary is found throughout Viet Nam.

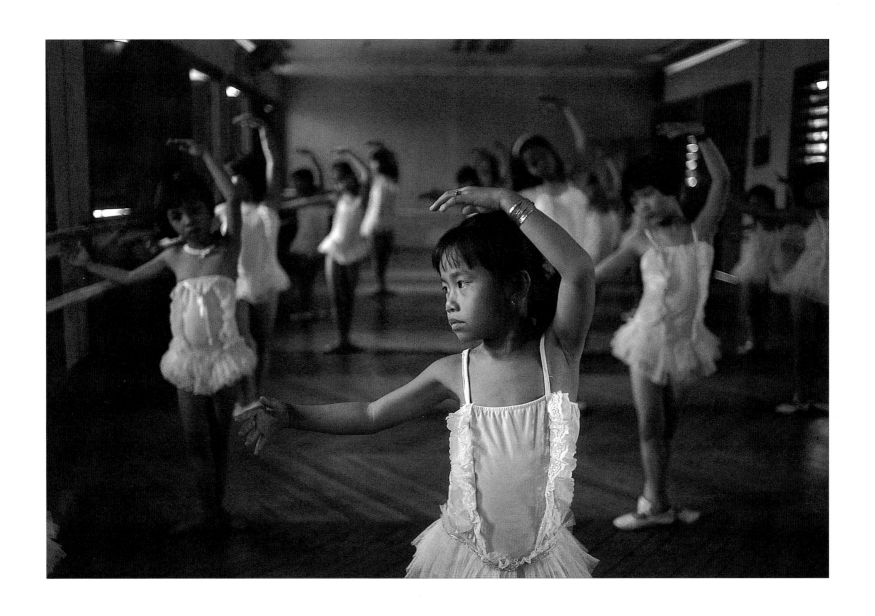

Young girls practice during their Sunday morning ballet class at an elementary school near Ho Chi Minh City.

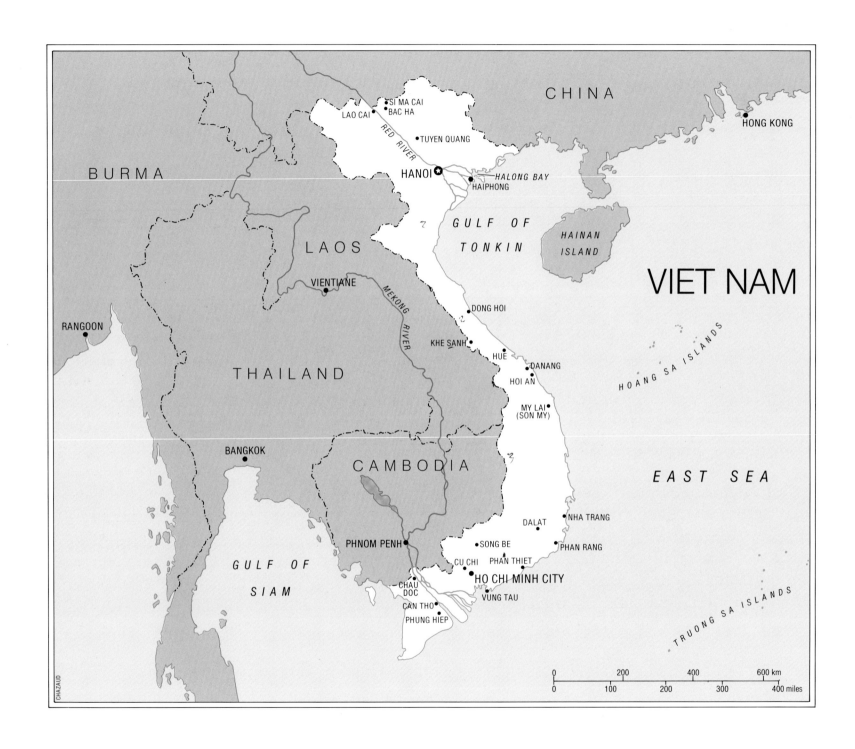

EPILOGUE

by Le Ly Hayslip

When I was a child growing up in the village of Ky La in Central Viet Nam, my parents told me the story of how our world came to exist. Long, long ago, before the earth was formed, two separate types of energy flowed through the darkness. When those energies collided, they exploded into light, and that explosion signified the merging of those two forms of energy—the positive and negative, the male and female, the *yin* and *yang*. For us, these energies have a name. *Cha Troi Me Dat*, we call them. Father Heaven and Mother Earth. And when they came together, they created the universe.

Father came to earth and made love to Mother, and their children are all the humans on this planet. We are all a part of them. And we aren't alone. Every water buffalo, every ant, even the dreams we dream each night, exist as part of the union between those two. At first, Father Heaven stayed down on earth with us and he taught us many good things. But then, too many of his children came to him asking questions he could not answer, demanding much more than he had already given, and becoming angry when their demands weren't met. After some time,

Father Heaven tired of his children's complaints and rose and returned to the heavens, leaving us with our Mother Earth. Although we continued to grow our rice, progress in our lives, and follow the laws of nature, something changed. No longer closely guided by the will of Heaven, we began to argue and fight. After that, our homeland rarely knew peace. We became a country at war.

As the war came to Ky La, this was the story my parents told to try to help me understand why the bombs were dropping all around us.

I left Viet Nam in 1970, when I was twenty years old. For sixteen years I made a life for myself in America. I finally returned to Viet Nam in 1986 and discovered a nation completely different from the one I had known as a child, that country of bombs and bullets, the wounded and the dead. Now I was seeing my country at peace, a nation still wounded, but nursing itself back to health. In 1988 I started the East Meets West Foundation so that Americans could contribute to this effort to heal the wounds in Viet Nam.

Much has changed in Viet Nam since I first returned there nine years ago. At that time, I could only enter the

119

country on the one Air France flight from Bangkok that went into Viet Nam every week. Now airlines from more than ten countries provide frequent service to both Ho Chi Minh City and Hanoi. The nation has opened its doors to hundreds of thousands of people from around the world, people anxious to witness the explosive growth of the newest Asian Tiger. In the last eight years, the East Meets West Foundation, as well as many other humanitarian organizations, has helped the victims of the war by offering wheelchairs, crutches, artificial legs, even artificial eyes.

Despite all these developments, I still sense a disharmony in Viet Nam. Most of the economic change is taking place in the cities. It hardly affects the peasants and farmers, who must constantly struggle simply to maintain their meager existence in the countryside. Many people still suffer from physical wounds or from the loss of loved ones who died in the war. Ten percent of South Viet Nam's surface area was poisoned when 18 million gallons of Agent Orange were emptied into the belly of our motherland. Over 2 million Vietnamese, from all parts of the country, were killed in the war. While the U.S. government moves forward in its search for its POWs and MIAs, Viet Nam has barely been able to touch on the question of the 300,000 Vietnamese who are still missing. Within the Vietnamese culture, this lack of knowledge about what happened to our loved ones amounts to spiritual torture. Vietnamese believe that the dead, if improperly buried, will wander forever as lost souls. Twenty years after the war ended, Viet Nam considers itself a country haunted by its dead, and many villagers refuse to leave their homes at night out of terror of the ghosts.

During the course of my work I have had the opportunity to look into the faces of men and women who are veterans from all sides and ask, How could this happen in the first place? How could we have done this to each other, and ourselves? The war has wounded us in terrible ways—not merely in our bodies but also in our souls. The work we have done to heal the bodies has helped to ease the suffering. But healing a wounded soul, I've found, is harder.

The Viet Nam War was not the first war and it certainly wasn't the last. Today, wars still go on around the world. This year marks the twentieth anniversary of the end of the war in Viet Nam. It marks the fiftieth anniversary of the end of World War II. Our parents went to war. They sent their children. And now we continue to send our own children off to die, or to return from war, also wounded. As in most cultures around the world, Vietnamese believe that one of a woman's roles in war lies in caring for the men defending our homeland. As a woman and a mother, I have witnessed too many young men coming back shattered.

Do we want or need to make this kind of sacrifice? I think not. I have traveled all over the world speaking with people about war. Some have made movies to protest the violence; others have written books. I sense a need in people's hearts and souls, a need for change, and this gives me hope. People are beginning to stand tall and demand that their leaders try a different tactic. As human beings, we are

here to grow, to progress, to help one another, to forgive each other, and, most of all, to give compassion to our brothers and sisters. Without compassion, none of the rest is going to happen. With compassion, I think we can fight and win the war of peace.

We must speak out. We must stand up. But we also have to keep things in balance. In the last five years, many of us have focused on how to help victims by building clinics to heal bodies. We also need to do what we can to heal souls. The Vietnamese have begun this task themselves. They have erected temples and shrines to help the lost and lonely souls, to establish places where the ghosts of war can finally rest. Americans, too, must recognize that the material life of the Vietnamese people is absolutely intertwined with the spiritual one. Just as Father Heaven and Mother Earth combined to form the universe, so too do the spiritual and physical combine to form the human soul.

Lou Dematteis's photographs capture both of these halves of Viet Nam, reflecting not only the vibrant detail of its daily life but also its deeper spiritual nature. If we as Americans can recognize these two very different but inseparable parts of Viet Nam, we can begin the next step in building our bridge of peace.

Much love and peace,
Le Ly Hayslip,
June 1995

Le Ly Hayslip is the author of When Heaven and Earth Changed Places *and* Child of War, Woman of Peace, *autobiographical accounts of her struggles in war-torn Viet Nam, her immigration to the United States, and her return visit to Viet Nam in 1986. In 1993, Oliver Stone made a movie about her experiences entitled* Heaven and Earth. *Two years after her return to Viet Nam, Ms. Hayslip founded the East Meets West Foundation in the United States, a humanitarian relief and development organization whose programs in Viet Nam include two medical centers, a residential center for displaced children, vocational schools, and various outreach projects serving impoverished families. East Meets West can be contacted at 870 Market St. #711, San Francisco, CA 94102; (415) 837-0490.*

NOTES ON THE PHOTOGRAPHS by Dana Sachs

Outside a temple in Ho Chi Minh City, actors take a break in their performance of the classical theater known as *Hat Boi* (page 74). With its extravagant costumes and makeup, highly formalized gestures, and dramatic, percussive music, *Hat Boi* (or *Hat Tuong*, as it is known in the North) has always drawn fans in Viet Nam. Today, though, it draws crowds. As Viet Nam races through an era of intense economic development, its people are turning backward and inward toward the ancient traditions that give Vietnamese culture its richness and its deepest, most spiritual meaning.

During the wars against France and the United States, and in the period of economic hardship that followed, Vietnamese rarely had the chance to visit a theater, take part in a religious celebration, or learn the rituals connected with the practice of ancestor worship. In 1986, the government introduced *doi moi*—the policy of economic renovation—and sparked the fires of massive economic change. People whose entrepreneurial ambitions had long been inhibited now threw themselves into private enterprise. Simultaneously, in the religious sphere, Vietnamese returned to the pagodas, temples, and churches, and, in the cultural realm, they began to rediscover such long-neglected traditions as *Hat Boi*, romantic love poetry, and fortune-telling.

The current transformation taking place in Viet Nam, which Lou Dematteis's photographs capture in countless forms, is the latest, and most peaceful, of the many, often violent disruptions to take place in this century. Since the beginning of World War II alone, the Vietnamese have fought the Japanese, French, Americans, Cambodians, and Chinese. A deep pride in Viet Nam's culture, tradition, and history helped the nation survive these traumas, but, at the same time, the Vietnamese still maintain a profound respect for change and innovation. Because of that respect, they value many foreign customs. They drink French coffee, use American slang, drive Japanese motorbikes, and listen to Mozart. Even the *Hat Boi* is derived from the operas of ancient China, a culture which subjugated its southern neighbor for centuries. Without allowing itself to be overwhelmed by foreign influence, Viet Nam has become a nation of cultural connoisseurs.

Dematteis's images show us the age-old traditions and the signs of social change, as well as the peculiar Vietnamese ability to incorporate the modern into the most basic aspects of cultural life. At a wedding party (page 78), a groom lifts his bride as if to carry her over the threshold into their new home. Because the groom wears a ceremonial headpiece and the women have donned *ao dai*, the Vietnamese national dress, the image appears to catch a ritual moment at a traditional wedding. In fact, the photograph offers a complicated collage of old and new. The gesture of lifting the bride has no roots in Vietnamese tradition: the groom, who lived for many years in France, is demonstrating for his new wife one of the customs he learned abroad. The bride, apparently, has already discovered Western styles on her own. A traditional Vietnamese wedding ensemble would hardly include stiletto heels.

The bride and groom appear to enjoy a degree of wealth, but we can see a similar tendency among poorer Vietnamese and across the spectrum of Viet Nam's many cultures. In the rice fields of the Mekong Delta, a barefoot farmer in work clothes (page 15) hasn't forgotten to strap his electronic watch around his wrist before heading off to the fields. In a remote mountain village in the North (page 45), Hmong minority women now use a Chinese sewing machine to produce their traditional clothing. Imported goods have become treasured symbols of the outside world. They ease the struggle of daily life and bestow status on the people who own them. They carry value for a more abstract reason as well. The freshness of something new causes a tiny but noticeable ripple in the often-stultifying monotony of rural life.

As thrilling as change can be, particularly within a society worn down by years of war and deprivation, some Vietnamese pause for breath. In books and journals, on canvas and on film, Viet Nam's artists and intellectuals now ask themselves certain thorny questions: How much development is too much? How do we protect our traditions? Which traditions deserve protection? And how do we respond to the threats that come with progress? In Viet Nam, for instance, the economic gap between rich and poor is widening. The nation now suffers from increasing drug addiction (page 60) and prostitution, while its ecological system lies threatened by unfettered development. In a Ho Chi Minh City neighborhood filled with narrow bicycle lanes and low-rise housing blocks, the construction of an enormous luxury hotel (page 25) becomes both a symbol of hope and a source of consternation as it snarls traffic and blocks out the sun. More noticeable still is the *sound* of development, the explosive, incessant noise of pile drivers, bulldozers, hammers, and drills. Even when construction eases, the traffic won't. Viet Nam now has twice as many cars and four times as

many motorbikes as it had in 1990 (page 34). And those numbers continue to rise.

Despite the perils of life today, few Vietnamese would wish themselves back in the past. Viet Nam enjoys more than simply increased economic security; it also enjoys the freedom to explore its ancient culture and religions, whether that be in the theaters of *Hat Boi*, at village festivals (page 93), or at the celebrations of Catholic holidays (page 39). Today, the rituals of lighting incense at a family altar or praying in a Buddhist pagoda play as much a role in contemporary Vietnamese life as riding a motorbike or watching TV. Foreign influence and social change bring a sense of hope to this society, but they carry with them new worries. Within the blare of traffic and through the fog of construction dust, today's Vietnamese cling to their ancient practices to give stability to their lives as Viet Nam accelerates into its loud, exhilarating, terrifying, and unknown future.

Dana Sachs has lived off and on in Viet Nam since 1990. She has written for The Far Eastern Economic Review, Mother Jones, Vietnam Investment Review, *and contributed to the book* Passage to Vietnam. *Her English translations of Vietnamese fiction will appear in three upcoming anthologies.* Which Way is East, *the award-winning documentary on contemporary Viet Nam that she made with filmmaker Lynne Sachs, has been screened across the United States and abroad.*

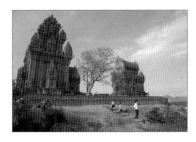

16/ From the second to the fifteenth centuries, the kingdom of Champa ruled a large area of present-day southern Viet Nam. A sophisticated society heavily influenced by Hinduism and Indian culture, the Cham continually fought the Vietnamese to the north and the Khmer to the west. Today, all that is left of the once-great empire are the 60,000 members of the Cham minority group, now practicing Muslims. Their ancient culture survives, however, in the masterful Cham Towers, many of which dot the arid landscape of South-Central Viet Nam.

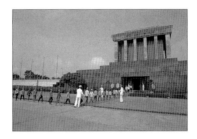

24/ While society changes all around them, Vietnamese continue to file past the embalmed body of Ho Chi Minh, who lies in state within the cool marble walls of the Hanoi mausoleum bearing his name. A devout nationalist whose varied careers included pastry chef, sailor, gardener, Communist Party founder, guerrilla leader, and statesman, Ho Chi Minh is known to Vietnamese as simply *Bac Ho*, Uncle Ho. Tirelessly working for Viet Nam's independence throughout his life, Ho died at age 79 on September 3, 1969, some six years before the reunification of his country.

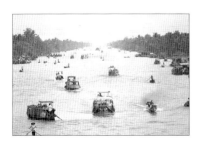

2/ Boats laden with goods make their way down a canal in the Mekong Delta, one of seven such canals that meet near the town of Phung Hiep. The Mekong River travels 2,000 miles from the Tibetan Plateau to the South China Sea, depositing enough silt to make the delta the most fertile region in Viet Nam. Over 20 percent of Viet Nam's people live here, the water providing them not only nourishment for their crops but, in a nation of limited roads and highways, an efficient means of transportation as well.

28/ At the shrine to a celebrated general from Mai Dong village near Hanoi, village elders perform rites to honor the 1,950th anniversary of his death. The tradition of ancestor worship dates back to ancient times, centering on the idea that the dead watch over the lives of their descendants. To make sure that their ancestors treat them well, families build altars and pay homage with incense and offerings. On the death anniversaries of famous historical figures, whole villages organize elaborate ceremonies to honor the spirits of the dead.

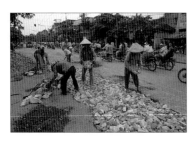

30/ According to the Vietnamese State Committee for Cooperation and Investment, the country had approved roughly $3.4 billion in foreign investment projects by the middle of 1995. While the nation's immense natural resources, educated population, and energetic labor force continue to attract foreign companies, its dilapidated infrastructure often scares them off. Much of the new investment will go toward upgrading the nation's roads, bridges, electric and water systems. But change takes time. Here, Hanoi laborers repair a major thoroughfare in the old-fashioned way.

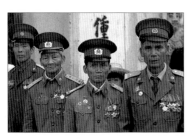

32/ Ask the Vietnamese about the war and they'll often reply, "Which one?" In this century alone, they've fought the Japanese, French, Americans, Cambodians, and Chinese. Here, a group of French War veterans participates in an ancestral festival in the village of Co Dien near Hanoi. In important strategic and ideological ways, the war against the French served as a precursor to and training ground for Viet Nam's next big conflict, which they remember as the American War.

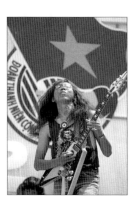

33/ Standing before the logo of the Ho Chi Minh Communist Youth League, guitarist/singer Nguyen Dat leads his band through a League-sponsored concert in Ho Chi Minh City. Although the look is Metallica, the sound is decidedly straightforward rock'n'roll. But even if Western ears might hear a bit of John Lennon in their original tunes, the band, one of the most popular in Viet Nam, doesn't forget its roots. Their name? *Da Vang*. Translation: Yellow Skin.

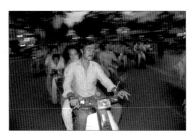

34/ In English, we'd call it "cruising" but the Vietnamese call it *chay rong rong*, "running around." On Sunday nights and holiday evenings, dressed-up urbanites drive up and down the streets, checking each other out. Often, whole families pile onto one vehicle, with Dad in front, Mom in back, and three or four little ones squeezed in between. Those who can't afford a motorbike make do with what they've got, whether a bicycle or merely their own two feet.

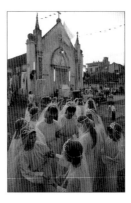

39/ Viet Nam has the largest Catholic population in Asia outside of the Philippines. European missionaries first introduced Catholicism to Viet Nam in the sixteenth century. During the French Colonial period, the practice of the religion flourished, as it did during the regime of South Viet Nam's President Ngo Dinh Diem, a Catholic who ruled from 1955 until his assassination in 1963. After a decline in religious practice following the war, Catholicism is now growing in popularity. In Haiphong, girls prepare for the Flowers for Mary celebration honoring the Virgin Mother.

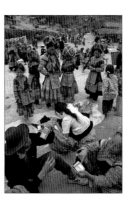

44/ During the 1979 Viet Nam–China War, the border region between the two countries endured the heaviest fighting. Conflict here is hardly new, though. Viet Nam has a several-thousand-year history of tension with its northern neighbor, and, despite current civility, the Vietnamese, at least, are always wary. At a market in Lao Cai Province, Hmong shoppers and Chinese merchants use the bank notes of both Viet Nam and China as currency. These days, the one-time battlefields serve as a center for both legal and illegal trade.

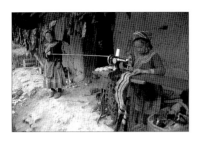

45/ One of 53 minority groups in Viet Nam, the Hmong people, who migrated south from China 200 years ago, still inhabit the remote areas near the Chinese border and still speak a Sino-Tibetan language. Now their culture is absorbing new influences, many of them from China. With increasing access to trade, Hmong seamstresses, famous for their exquisite clothing made with natural dyes, have begun to integrate synthetic materials into traditional designs. Here, a Hmong woman sews a piece of machine-made fabric onto the hand-embroidered section of a skirt.

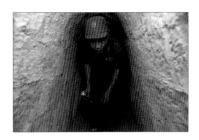

57/ A Vietnamese soldier, doubling as a tour guide, crawls through a passageway at Cu Chi. This National Liberation Front (Viet Cong) tunnel complex once stretched all the way from Saigon to the Cambodian border. Often running just beneath the feet of South Vietnamese and American forces, the tunnels became virtual cities, containing living quarters, hospitals, command centers, kitchens, and weapons factories. Brilliant as it was, fewer than half of the soldiers who lived here survived. Today, Cu Chi is a favorite stop for foreign tourists.

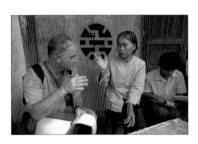

53/ U.S. Army Chief Warrant Officer Thomas McKay, a member of the U.S. MIA/POW search team, interviews a woman in Dong Nai Province east of Ho Chi Minh City. The U.S. government made accounting for its missing servicemen a top priority in normalizing relations with Viet Nam. As of July 1995, approximately 1,600 Americans were still listed as missing in Viet Nam. At the same time, Viet Nam is involved in a search of its own, accounting for the estimated 300,000 Vietnamese still missing since the war.

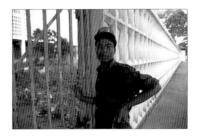

59/ Living legacies of the American War, Amerasian children, like this young man standing in front of the former U.S. Embassy in Saigon, have most always faced a hard life and bleak future in Viet Nam. Although some 5,000 children fathered by Americans remain, more than 20,000 others have used the U.S. government's Amerasian Homecoming Act to seek a happier life in the States. Many of these new Americans can't read, write, or speak English, however, and find life in their new home can be as harrowing as life in the old one.

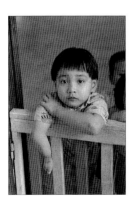

55/ Operating from a Saigon control room bearing a plaque that read, "Only You Can Prevent Forests," the U.S. military dropped 11 million gallons of defoliants on Viet Nam during the war in an effort to destroy natural cover for enemy bases. The program did more than devastate the ecosystem. In the areas heavily hit by the dioxin-laced Agent Orange, doctors have noted a significant rise in liver cancer, in the incidence of Siamese twins, and, as with this child at the Tu Du Women's Hospital in Ho Chi Minh City, in birth defects.

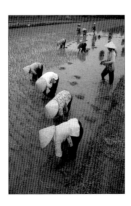

68/ In Vietnamese traditional life, time moves cyclically, as farmers concentrate on the waxing and waning of the moon, the changing of the seasons, and the planting and harvesting of rice. As dedicated as Vietnamese have always been to growing their staple crop, for much of the 1980s the nation had to import rice to feed itself. In 1986, the government instituted economic reforms, and by 1991, Viet Nam had become the world's third leading rice exporter. Here, women in the Mekong Delta transplant seedlings to give the plants room to grow.

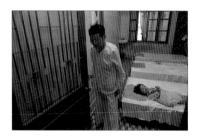

70/ Founded in 1988 by Vietnamese-American writer Le Ly Hayslip, the East Meets West Foundation raises money in the United States to support projects in Viet Nam. The foundation strives to provide quality health care, education, vocational training, and rehabilitation. In the Peace Village Medical Center at China Beach, near Danang, four Vietnamese doctors treat 100 patients per day, six days a week. The center offers both Eastern and Western medicine to its patients. Here, an older patient leaves the acupuncture clinic as a younger one receives treatment.

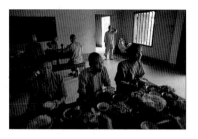

77/ For centuries, Buddhism has helped shape Viet Nam's spiritual life. Here, monks and workers share a communal meal at the Thien Mu Pagoda in Hue. Overlooking the Perfume River, Thien Mu is famous for its beauty and for the social activism of its monks. A photograph of one of those monks, Thich Quang Duc, circulated the world after he immolated himself on a Saigon street in 1963, protesting the South Vietnamese regime's repression of Buddhists. Today, the Thien Mu monks retain their commitment to activism, even with the change in government.

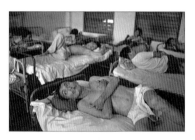

71/ Addicts go through withdrawal at Ho Chi Minh City's Drug Abuse Tackling and Prevention Center. Drug abuse is hardly a new problem in Viet Nam, but now it's on the rise. Before 1975, users injected heroin; today it's liquid opium. The most serious danger, of course, is AIDS. Despite a government campaign to educate citizens about the virus, a 1993 CARE International study showed that many Vietnamese aren't protecting themselves. In one foreboding sign of things to come, 73 percent of these drug addicts have tested HIV-positive.

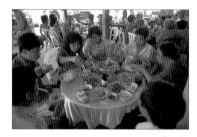

79/ In the past several decades, few Vietnamese had a chance to take a vacation. Now many more do. The spruced-up eateries along the country's main North-South artery, Highway One, reflect a significant increase in disposable income. Only a few years ago, travelers searching for a bite to eat could hope for little more than a bowl of chicken soup or a loaf of dried-out bread. Today's travelers—those with money, at least—can enjoy the specialities of whatever region they're passing through.

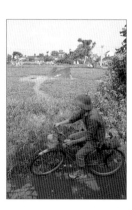

72/ The U.S. military called it Linebacker II, but history remembers it as "the Christmas Bombings." For eleven days, beginning December 18, 1972, U.S. aircraft bombed North Viet Nam, taking one 36-hour break for Christmas. Historians don't agree whether these missions specifically targeted civilian areas or not, but few argue with the Vietnamese tallies of over 1,600 civilians dead in Hanoi and Haiphong. The Vietnamese shot down fifteen B-52s; the wreckage of one lies in this Hanoi pond.

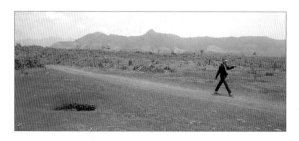

88-89/ A local farmer walks across the deserted airstrip at the site of the former U.S. Marine Combat Base at Khe Sanh. Located in mountainous Quang Tri Province near the Demilitarized Zone, Khe Sanh was the site of the single largest battle of the war. On January 21, 1968, North Vietnamese troops began a 75-day siege, which resulted in hundreds of American and thousands of Vietnamese deaths. The siege served to divert U.S. attention from the Tet Offensive, which began ten days later.

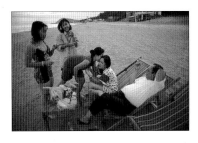

90/ A Vietnamese visiting from the United States treats his family, who still live in Ho Chi Minh City, to a day at Vung Tau's beach. After the government opened its doors to the West in 1986, a trickle of overseas Vietnamese, or *Viet Kieu*, began to make visits home. Today, that trickle has turned into a flood. The one-time refugees, many of whom are now comfortably middle class, come back for many reasons: to visit family, to return to the graves of their ancestors, to invest in businesses, and increasingly, just for fun.

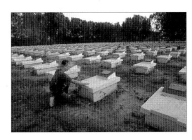

106/ When Viet Nam began opening to the west in the 1980s, American Viet Nam War veterans were among the first to arrive, many seeking to heal the lingering psychological wounds of war. At the Cu Chi Cemetery for War Martyrs, U.S. veteran Robert Shippen places incense on the grave of a National Liberation Front soldier. Shippen returned to Vietnam with other American vets on a project sponsored by the California-based Veterans' Viet Nam Restoration Project. This tour's mission: to reconstruct a health clinic in the nearby town of Cu Chi.

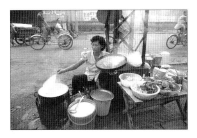

94/ One popular way to say hello in Viet Nam, "*An com chua?*" means, literally, "Have you eaten rice yet?" Rice, the staple of the Vietnamese diet, appears in many forms, from steamed rice and noodles to sticky rice and porridge. Here, a Ho Chi Minh City street vendor cooks and sells *banh cuon*, steamed rice-flour pancakes. While this vendor stays in one place for the day, others hang their pots and pans off bamboo poles, balance the contraption on their shoulder, and wander the streets in search of customers.

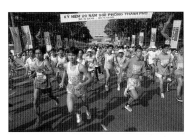

108/ American manufacturers could only begin to market their products in Viet Nam after the U.S. trade embargo was lifted. Now, they're racing to catch up with their foreign competitors in the fast-growing Vietnamese market. Pepsi-Cola got its name out by sponsoring the 1995 Ho Chi Minh City Marathon, which took place the week before the twentieth anniversary of the fall of Saigon (now known as Ho Chi Minh City). The banner over the runners' heads reads: "20th Anniversary of the Liberation of the City."

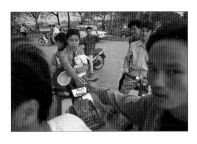

97/ Viet Nam has a tradition of naming its roads for important historical and political figures. Perhaps none of these names is more apt, however, than that of the Hanoi road that bears the simple moniker *Thanh Nien*, meaning Youth. A causeway stretching between two of Hanoi's most beautiful—and romantic—lakes, Youth Road has become a favorite hangout for the city's young people. On summer nights, couples head for the shadows by the edge of the moon-dappled lakes, and turn their parked motorbikes into settings for love.

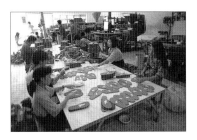

109/ Today, foreign products like Heineken and Honda dot the shelves and showrooms of Viet Nam. At least one major product, though, is purely Vietnamese. Founded in 1982, the privately owned shoe manufacturer Binhtien Imex Corporation—better known as *biti's*—has 300 outlets nationwide. Factories like this one produce 12 million pairs of shoes annually, for both domestic and foreign buyers. Now *biti's* is waiting for the United States to grant Viet Nam Most Favored Nation status, so it can set foot in the American market, so to speak.

ACKNOWLEDGMENTS

My deepest appreciation goes to all those who helped this project along its way. First and foremost, I am deeply indebted to the late Dr. Bill Eisman of the U.S./Vietnam Friendship Association. Bill supported and encouraged me from the start, securing my first invitation to visit Viet Nam and introducing me to the Vietnamese Photographic Artists Association. Thanks also to Bill's wife Bea, who carries on their work and who shared with me her extensive knowledge of Viet Nam and its history.

The Vietnamese Photographic Artists Association was instrumental in this work, and I'm very grateful to its members for their support, especially Mr. Van Bao in Hanoi and Mr. Lam Tan Tai in Ho Chi Minh City. A special thanks goes to Mr. Doan Duc Minh, without whose help this book would not exist in its present form. Photographer extraordinaire, Minh was my translator, fixer, confidant, companion, friend, and sometimes driver throughout much of my time in Viet Nam. Thanks as well to Mr. Duc Chinh for making our trip to the far north such a success, and to Mrs. Linh Phuong in Can Tho for opening her heart and sharing her story.

On the home front, I'm forever grateful to my wife Maria, who kept house and home together during my many absences. Thanks as well to our daughter Candida for helping her mother and watching over my business affairs. And thanks to my father for teaching me to pursue the truth, my mother for her strength, and my brother and sisters for their love and support.

Special thanks to Lisa Spivey of "Destination: Vietnam," who believed in the project from the beginning and always found a way to keep it going. Thanks also to Albert Wen, Lisa's co-publisher, for his support and sense of humor. I'm indebted also to photographers Bob Gumpert, Kim Komenich, Rick Rocamora, and Chris Vail for their valuable help throughout the editing process. I thank Le Ly Hayslip for her inspirational work and for bringing Oliver Stone into the project. To Oliver, my appreciation for writing the Foreword even while immersed in film production, and thanks as well to Annie Mei-Ling Tien of Ixtlan productions for her support.

My gratitude to Reuters for giving me work in Viet Nam which helped pay the bills. Thanks to Bob Schnitzlein and Larry Rubenstein in Washington, Bill Creighton and Rob Taggert in Hong Kong, and Kat Callow, John Rogers, and Claro Cortes in Hanoi.

Thanks to my editors at Norton, Jim Mairs, Bill Rusin, and Tabitha Griffin, for keeping the project alive and giving me valuable direction, and to Candace Maté for helping me select the images. Thanks as well to Peter Morgan, Mary Sui, Lucinda Covert, Mauro Marinelli, Abby Robinson, Bert Fox, Neal Menschel, and Susan Meiselas, and to Jocelyne Benzakin and the staff of JB Pictures. In California, thanks to Violette Yacoub, Tom Kelly, Dana Sachs, Matthew Naythons, Michele Vignes, Richard Bermack, Ken Light, Sherry LaVars, the New Lab, and DHL Worldwide Express. In Viet Nam, thanks to Barbara Cohen, Peter Saidel, Jason Bleibtreu, Rebeca Ramos, Radhi Chalasani, and Kristen Huckshorn for their advice and company, and in Bangkok, thanks to K.O., Sandy Cate, and Angus McSwan for opening their homes to me.

Last, but certainly not least, thanks to the people of Viet Nam who welcomed me to their land and let me photograph their lives.

ABOUT THE PHOTOGRAPHER

Lou Dematteis has spent much of the last twenty years working in Mexico, the Caribbean, Central and South America, Europe, and Asia. A former staff photographer with Reuters, Dematteis was based in Managua, Nicaragua, during the height of the U.S.-backed Contra war. In 1986, his photographs of downed U.S. soldier-of-fortune Eugene Hasenfus received international recognition, including a citation from the World Press Photo competition and inclusion in the *New York Times*'s and National Press Photographers Association's Pictures of the Year. His photographic anthology, *Nicaragua: A Decade of Revolution,* was published by Norton in 1991.

Dematteis's photos have been widely exhibited in the United States and abroad, including showings at the Ansel Adams Center in San Francisco and the Photographers Gallery in London. In 1992, he directed and participated in the first exhibit by U.S. photographers in Viet Nam since the end of the war; and in fall 1994, he presented the first exhibit by Vietnamese photographers to show in the United States as well. Dematteis is now based in San Francisco, California, and represented by J.B. Pictures, New York City.